ALABAMA
FOOTBALL TALES

MORE THAN A CENTURY OF
CRIMSON TIDE GLORY

LEWIS BOWLING

THE
History
PRESS

Published by The History Press
Charleston, SC 29403
www.historypress.net

Copyright © 2012 by Lewis Bowling
All rights reserved

Cover images: Photo of Bryant-Denny Stadium by Carol M. Highsmith, from the Library of Congress George F. Landegger Alabama Collection; Photo of Big Al mascot by Carol M. Highsmith, from the Library of Congress George F. Landegger Alabama Collection.

First published 2012
Second printing 2014
Third printing 2017

Manufactured in the United States

ISBN 978.1.60949.722.4

Library of Congress Cataloging-in-Publication Data

Bowling, Lewis.
Alabama football tales : more than a century of Crimson Tide glory / Lewis Bowling.
p. cm.
ISBN 978-1-60949-722-4
1. University of Alabama--Football--Anecdotes. 2. Alabama Crimson Tide (Football team)--Anecdotes. I. Title.
GV958.U513B68 2012
796.332'630976184--dc23
2012031178

In memory of Ollie Lee Bowling IV,
quite the sportsman himself.

CONTENTS

Acknowledgements

As with any book, many people and resources were helpful to me. My wife, Beth Harward Bowling, does most of my typing and editing, along with helping me stay on track. She really deserves as much credit as anyone for all my books, including this one. Thanks to Will McKay, Jaime Muehl and Jamie Barreto at The History Press in Charleston, South Carolina, for their guidance in writing and publishing this book. A special thank you goes to Brad Green at the Bear Bryant Museum in Tuscaloosa. Brad helped me with finding research material and pictures and always responded promptly to my e-mails. People such as Brad, along with Ken Gaddy and Taylor Watson at the Bear Bryant Museum in Tuscaloosa, are the kind who make Alabama football special. One person I miss seeing at the museum now is Clem Gryska, the longtime assistant coach to Bear Bryant, who was as much a part of the museum as anyone. Coach Gryska really knew his Alabama football and would share his wisdom with you with a warm smile and greeting. I used resources from the Hoole Library at the University of Alabama and even found some information in the Perkins Library at Duke University. I met with Mal Moore, Alabama's athletic director and former player and assistant coach; Hootie Ingram, former Alabama athletic director and player; Don Salls, former Tide player; Frank Thomas Jr., son of legendary former Alabama coach Frank Thomas; David Cutcliffe, now Duke head coach and an Alabama graduate; and Polly Drew Jansen, daughter of former Alabama coach Red Drew, among others. I had several long talks with Harry Gilmer and Vaughan Mancha, two former

Tide All-Americans. T.J. Weist, a former player at Alabama and now an assistant coach at the University of Cincinnati, has been very helpful to me with information on Alabama football. Coach Weist is an avid collector of Crimson Tide football memorabilia.

I

"WE THEREFORE GOT RID OF HIM"

Being head coach at Alabama has its advantages. Holding that position makes you the most recognizable person in the entire state. But it can be a tough job, especially if you don't win. A school such as Alabama that has won fourteen national titles expects championships on the field, along with beating Auburn almost every year.

You had to win at Alabama from the beginning days of football in Tuscaloosa. In 1892, Alabama's very first team, coached by E.B. Beaumont, won two and lost two. They won the first game against Birmingham High School, 56–0. Alabama split its next two games with Birmingham Athletic Club but lost to Auburn in the first-ever meeting between those two rivals. Auburn won 32–22 in front of five thousand fans in Birmingham.

Now, you might think that a .500 record in the school's first year of playing football would get Coach Beaumont a second year to coach the team. The school yearbook, *The Corolla*, described his selection as coach as "unfortunate." *The Corolla* also reported that Beaumont had "very limited" knowledge of football. "We therefore got rid of him."

As you can see, being head coach at Alabama was not going to be easy, not in 1892 and not today.

Of course, not all coaches at Alabama have been so well compensated as current coach Nick Saban. In 1896, Alabama hired Otto Wagonhurst, who was to be paid $750 for the season. But the senior class could only raise $50. In 1926, after Alabama won the national title by beating Washington in the

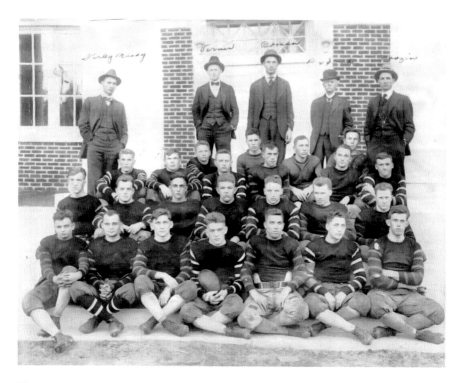

The 1915 team at Alabama was coached by Thomas Kelly. The Tide won six games with two losses. Alabama beat Sewanee 23–10 and beat Ole Miss 53–0. They traveled to Austin, Texas, and lost to Texas 20–0. Bully Vandegraaf, who is on the far right on the first row, became Alabama's first All-American football player in 1915. *Courtesy of Paul Bryant Museum.*

Rose Bowl, the Athletic Association got in touch with Wagonhurst and paid him the remaining portion of his salary.

In 1906, Dartmouth alumnus Coach Doc Pollard was hired. Coach Pollard deserves credit for bringing the first real period of winning years in Alabama football history. His record in his four years from 1906 to 1909 was twenty-one wins and four losses. Alabama beat Tennessee all four of those years.

Pollard was the coach in 1907 when Alabama played Auburn. When negotiations started for a contract to play the game in 1908, officials at both schools argued back and forth over such issues as player eligibility, illegal formations, how many players could suit up and who would be the officials, among other points of disagreement. The teams couldn't come to an agreement and didn't play again until 1948.

In 1911, D.V. Graves was hired. Graves was a former coach at Blee's Military Institute in Missouri. Honest to a fault, Graves said after Alabama

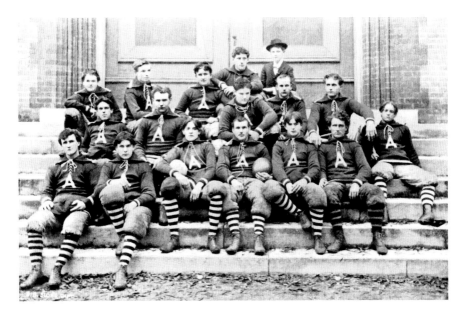

The 1896 team won two games with one loss under coach Otto Wagonhurst. The two wins were over the Birmingham Athletic Club and Mississippi State, and they lost to Sewanee. S.B. Slone served as captain of the team. *Courtesy of Paul Bryant Museum.*

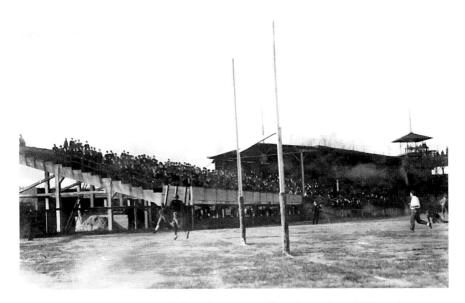

An Alabama player scores a touchdown in a game in Tuscaloosa about 1915 at what was then called University Field (renamed Denny Field in 1920, after George Denny, the longtime president of the university). *Courtesy of Paul Bryant Museum.*

selected him, "I know nothing of southern football nor how Alabama ranks in comparison. The team is rather green in the so-called rudiments of the game. We have some big linemen, slow and clumsy, who with lots of practice ought to be fair linemen by November."

But Dorsett Vandeventer Graves had a respectable record in his four years at the Capstone (University of Alabama), winning twenty-one games with twelve losses. Not only that, but Coach Graves also coached basketball and baseball while at Alabama. He would go on to be head baseball coach at the University of Washington from 1923 to 1946 and is now enshrined in the University of Washington Hall of Fame. For his entire coaching career, Graves had winning records in all three sports he coached. He was 32-18 in football, 50-27 in basketball and 347-219 in baseball.

In 1913, under Coach Graves's tenure, Alabama beat Birmingham Southern by a whopping 81–0, and in 1914, the Tide beat Georgia Tech for the first time. But against one of its main rivals of the era, Sewanee, Alabama was winless during Graves's tenure.

As was mentioned, coaching at Alabama is not easy. Following the 1913 season—which was pretty successful, with a 6-3 record—the howling started about Graves. While nowadays a season with three losses sends Bama fans into mourning, the Crimson Tide didn't become a national power until the 1920s under Wallace Wade. A writer for a Birmingham newspaper noted the following:

> *It seems that the coach question has again put in its appearance to make lively the post mortem discussion on the 1913 football season at Alabama. There are quite a number of alumni of the Tuscaloosa institution who like to whoop 'em up when the football team wins. But the Crimson victories in the last three years haven't been sufficiently numerous to cause aforesaid alumni to exercise their lungs unduly. As a result thereof, there have been some who confessed a feeling of humiliation in regard to Alabama. It is only natural—and more often than not, it is just, to lay repeated defeat at the doors of the coach. It may be, therefore, that the wish is that another coach would replace Graves.*

An assistant coach (Dietz) for the Carlisle Indians was rumored to be the replacement coach. But the new president of Alabama, George Denny, denied strongly that a change would be made. A local paper ran a big headline: "President Denny Denies That Indian or Any Other Coach Will Replace Graves."

More Than a Century of Crimson Tide Glory

As you can see, Crimson Tide football has been attracting large, enthusiastic crowds to games in Tuscaloosa since the start of football at Alabama in 1892. This picture is from the early 1900s. Over 100,000 fans attend every home game at Bryant-Denny Stadium today. *Courtesy of Paul Bryant Museum.*

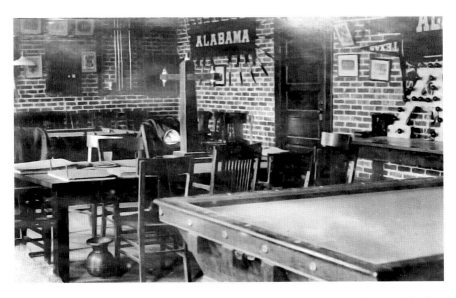

This was the A-Club room for football players sometime before 1920. *Courtesy of Paul Bryant Museum.*

Coach Graves did get another year and went 5-4, with losses to Tennessee, Sewanee, Mississippi State and, in the last game of the 1914 season, the Indians of Carlisle. (No, Alabama didn't play against the great Jim Thorpe, who finished his career at the Indian boarding school in Carlisle, Pennsylvania, in 1912.)

In 1915, Thomas Kelly was hired to coach the Tide. Kelly had played football at the University of Chicago under famed coach Amos Alonzo Stagg.

Perhaps the best opening five games of any Alabama coach would be credited to Kelly in 1915. Alabama beat Samford 44–0, Birmingham Southern 67–0, Mississippi College 40–0 and Tulane 16–0. So by the time Alabama played Sewanee on October 30, the Tide had outscored its four opponents 167 to 0. Alabama then beat Sewanee, perhaps the most powerful team in the South at the time, 23–10 (this game is covered in more detail elsewhere in this book).

I had the opportunity to see the old Sewanee campus, what is today called the University of the South, when I gave a dedication speech for a Wallace Wade memorial in Tullahoma, Tennessee, in 2011. Tullahoma is about thirty miles from Sewanee. Coach Wade, who led Alabama to its first national title, coached high school football in Tullahoma for two years in 1919 and 1920. His 1920 team won the Tennessee high school state championship, going undefeated.

Kelly went 6-2, 6-3 and 5-2 in 1915, 1916 and 1917. He later served as head coach at Idaho and Missouri.

Coach Xen Scott arrived in Tuscaloosa in 1919 and had outstanding success, winning twenty-nine games and losing nine in his four seasons from 1919 to 1922. A win over Penn in 1922 gave Alabama some national recognition. Alabama traveled to Franklin Field, the home turf of eastern power Penn. Eastern teams dominated teams from the South, so Penn was a big favorite. But twenty-five thousand stunned fans saw Scott's gallant southern boys win 9-7. Upon arriving back in Tuscaloosa, a huge crowd welcomed the boys at the train depot. Al Clemens, a player that year, recalled, "They had three big flatbed trucks pulled by horses. They hitched them together, and we stood up on them and waved as we were pulled through the center of town."

Tragically, cancer forced Scott to resign after the 1922 season, and he passed away in 1924.

In 1923, Alabama hired William Wallace Wade, and football in Tuscaloosa would never be the same.

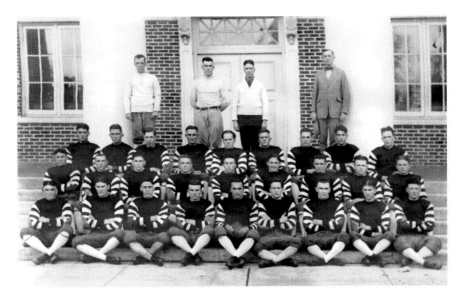

The 1921 team, coached by Xen Scott (pictured in the top row, far left), finished 5-4-2. Alabama played LSU to a 7–7 tie in New Orleans. Al Clemens served as team captain. *Courtesy of Paul Bryant Museum.*

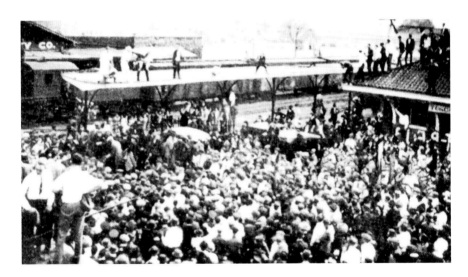

Fans flocked to the Tuscaloosa Depot to welcome home the Crimson Tide team after its dramatic upset over Penn in Philadelphia in 1922, which shocked the nation. At this time, southern football was considered inferior to most other sections of the country. *Courtesy of Paul Bryant Museum.*

2

BULLY AND THE DANGLING EAR EPISODE

The University of the South, still called Sewanee by many, used to regularly beat the University of Alabama in football. Located in Sewanee, Tennessee, Sewanee was a football powerhouse, especially in the 1890s. The 1899 team won all twelve of its games, and eleven were shutouts. Five of those wins came in a six-day period while on a 2,500-mile train trip.

Sewanee beat Alabama 20–0 in 1893, Alabama's second season of playing football. But in 1894, Alabama beat Sewanee 24–4. The next nine times these two teams played, Sewanee won, and often in convincing fashion, such as 42–6 in 1905 and 54–4 in 1907.

In 1915, Alabama had "Bully" on its team—one William Vandegraaf, better known as Bully. Alabama won 23–10 as Bully kicked three field goals, intercepted a pass and returned it for a touchdown and punted a ball that covered seventy-eight yards by air and bounce.

Bully Vandegraaf was the first All-American football player in Alabama history. He stood six-foot-two and weighed 185 pounds, which was huge for his day. Bully was tough, too, but it would be hard to match the toughness of his brother, Hargrove. Hargrove was one of three Vandegraaf brothers who played football for Alabama. Adrian was the third.

In a game against Tennessee in 1913, Hargrove nearly lost an ear in what is referred to by some as the "dangling ear episode." Tennessee tackle Bull Bayer recalled what happened: "Vandegraaf had a real nasty cut, and the ear was dangling from his head, bleeding badly. He grabbed his ear and tried

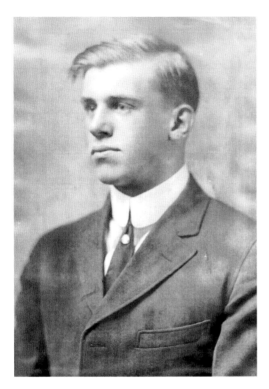

William "Bully" Vandegraaf became Alabama's first All-American player in 1915. He scored seventeen of Alabama's twenty-three points in a big win over Sewanee. In 1912, Bully played on the Alabama team with two of his brothers, Adrian and Hargrove. Their father, Adrian Sr., played for Yale in 1880. *Courtesy of Paul Bryant Museum.*

to yank it from his head. His teammates stopped him, and his managers bandaged him. He wanted to tear off his own ear so he could keep playing."

The Vandegraaf boys learned to love football from their father, Adrian Sr., who played for Yale way back in football's infancy, in 1880. The elder Vandegraaf played on the scrub, or "second eleven," of Yale. Not only did he play football at Yale, but Vandegraaf, along with teammate Henry White, was also instrumental in getting Yale's first athletic field.

Walter Camp, considered by many to be college football's founding father, himself a former player and coach of great Yale teams, wrote about Adrian Vandegraaf Sr.:

> *Back in the very early 1880s at Yale, a group of men at Yale College, as it was then not satisfied with the athletic facilities offered by the rental of a place called Hamilton Park—a field surrounded by a horse track— determined to make an effort to raise money for a field for Yale of its own. These two men were Adrian Sebastian Vandegraaf and Henry C. White, both men of particular promise in the scholastic work of the university. They started the ball rolling and before it stopped a sufficient fund had been*

subscribed to make possible the purchase, with a considerable mortgage, of some 25 acres of land in the western portion of the city, which became the Yale field. Vandegraaf went to Alabama and followed the legal profession. A few years ago I learned that Vandegraaf's boys are playing football, and playing a good game, and since then have been following their career with particular interest. Bully is the star of them all. He plays tackle, but drops back to kick, and for the last two years has been the best kicker in the south. He stands 6 feet 2 inches in his stockings and strips at 185 pounds. Besides that he is very fast, sturdy, and accurate. He is just over 20 and this is his fourth year on the Alabama team, where he played first at 16. This year it was Vandegraaf that enabled Alabama to defeat Sewanee for the first time in nearly a score of years.

This publicity given to the Vandegraafs and Alabama's win over Sewanee in 1915 was really the first national recognition of Alabama football. Many histories of Crimson Tide football point to Alabama's upset over Penn in 1922, and for sure Alabama's upset over Washington in the 1926 Rose Bowl gave Alabama more of the national spotlight. But Walter Camp, when he wrote about the Vandegraafs in 1915, was easily the most recognized name in college football. The 1915 season in which Alabama beat a powerful Sewanee program and Bully Vandegraaf became Alabama's first All-American garnered the first real national acclaim for the Crimson Tide program, which today stands as perhaps the most storied program in all of college football history.

Burton Brown, a well-known sportswriter from New York City, had heard about the exploits of Bully during the 1915 season and wrote a letter to Alabama's coach, Thomas Kelly. The letter was dated December 6, 1915:

Dear Sir, I am anxious to show the people up here a real football player, so I am writing you hoping that you can send me a photograph of Vandegraaf and some data on his great performances this year. I hope you can send me this material at an early date so that I can boost this good player and also the university. I want to write a story around him. Very Sincerely, Burton S. Brown.

Sure enough, in his "Sportographs of the Amateurs" column later in December, which was nationally read, Brown gave Bully his due. Giving a player from the South such national acclaim was very rare in 1915, as southern football was not considered to be on par with schools from the

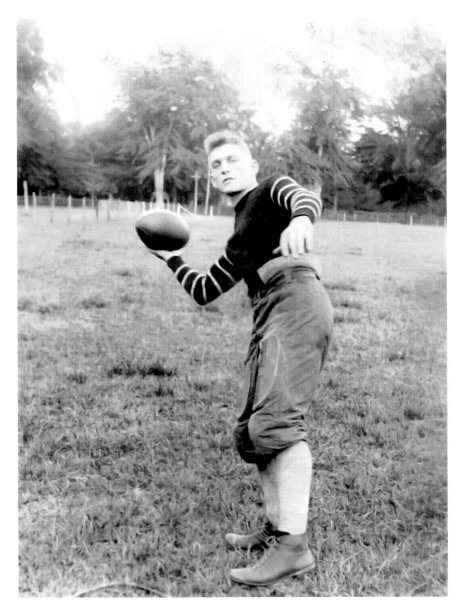

William L. Harsh gets ready to throw the ball in 1915. Harsh was a halfback from Birmingham. *Courtesy of Paul Bryant Museum.*

North, West and Midwest. To give an example, when Walter Camp selected his 1915 All-American team, Bully was the only southern player to make the first or second teams.

Brown wrote about Bully and ran a nice picture of him in uniform:

> *Bully is the last of the Vandegraaf gridiron stars of Alabama, and the best football player ever developed in the south. He is the youngest of a trio of giants who are as famous in the south as the Poes are at Princeton. Since 1908 there has been a Vandegraaf on the varsity team of the University of Alabama, and in 1912 the three brothers played together and were truly a mighty force. All the schoolboys of Alabama are hoping that some day they may be as great as Bully. He kicked twelve goals from the field this year, and did the best long distance punting in the country.*

John Heisman, for whom the Heisman Trophy is named, was the Georgia Tech coach in 1915. Tech was undefeated that year and beat Alabama 21–7. But after the game, Heisman had nothing but praise for Bully:

> *At Tuscaloosa, they put Vandegraaf in the lineup as left tackle, but how they figure it that way I find myself unable to understand. When Alabama wants to punt, they call him back to the full's position, and he does the punting. Do you want a forward pass? Well, Bully is back there and does that well, too. When it comes to bucking the line, why, its good old Bully back there, and here he comes. If he takes the notion he will run around the end for about half a mile, but still they call him a tackle at Tuscaloosa. When it comes to defense, here's Bully not stationed where you would usually look for a left tackle but backing up squarely behind the middle of the line.*

In other words, Bully played all over the field, as Coach Heisman found out when his Techsters played the Tide.

Zipp Newman, perhaps the most famed sportswriter of his time, wrote that Vandegraaf could "knock out tacklers with his high stepping knee action."

Bully became an assistant coach at Alabama under Xen Scott and Wallace Wade. He went to Colorado College in 1926 as head coach and stayed through 1939. He then went on to a distinguished army career and retired as a lieutenant colonel. Bully Vandegraaf passed away in 1977 in Colorado Springs, Colorado.

3

"THAT COW COLLEGE ON THE OTHER SIDE OF THE STATE"

Can you fathom Nick Saban, Alabama head man, coaching the 2012 Tide and then switching to Auburn to coach in 2013? No? I can't either. But there is precedent for such a move.

Mike Harvey was the head coach at Alabama in 1901, when the Tide finished 2-1-2. Harvey was then head coach at Auburn for the last two games of the 1902 season, going 0-2. Harvey served as an assistant coach at Auburn for the first few games in 1902, including a 23–0 win over Alabama on October 18.

Years later, Platt Boyd, a nephew of Mike Harvey, recalled something Harvey had told him about the Alabama-Auburn game of 1902, when Harvey was an assistant coach for Auburn:

> He had an argument with the Alabama coach, Eli Abbott, about the pants the Alabama players wore. He remembered the year before when Alabama players had handles stuck on the back of their pants so they could throw the ball carrier forward and could lock to each other when setting up a V wedge when blocking. Uncle Mike insisted that those handles be cut off before the game.

Auburn beat Alabama 53–5 in the 1900 game, and when Alabama didn't at first sign a contract for the 1901 game, Auburn followers claimed the Alabama team was scared to play them. About a week before the game, the contract was signed. Auburn beat Alabama again, this time 17–0. The *Birmingham News* ran a big headline on November 16, the day after the game, which was played in Tuscaloosa:

Joe Sewell played football and baseball at Alabama through the 1919 season but then went on to an outstanding major-league baseball career. Sewell put the bat on the ball perhaps as well as any player ever. He struck out only 114 times in 7,132 at-bats for an average of one strikeout every 63 at-bats, the lowest average of any player in history. Sewell batted .312 for his career, with 2,226 hits. He was on two World Series champion teams. The baseball stadium at Alabama is named Sewell-Thomas Stadium, in honor of Sewell and Alabama football coach Frank Thomas, a big baseball fan. One writer said about Sewell the baseball player: "Note that he has wide-awake eyes and that he takes a cut on the ball that gets results." *Courtesy of Paul Bryant Museum.*

AUBURN'S TIGERS Win The Game From Alabama Team
A CLEAN FAIR STRUGGLE
THE VISITORS WERE TOO HEAVY

When the series resumed in 1948, after forty-one years of not playing, there have been many memorable games between Alabama and Auburn. In 1971, Alabama was 10-0 and Auburn was 9-0 heading into the game, which Bama won, 31–7. In 1982, Auburn's Bo Jackson jumped over the top of the pile from the 1-yard line with two minutes remaining to give Auburn a 23–22 win. The victory ended Alabama's nine-game winning streak over Auburn. Bo Jackson did it to Alabama again in 1983 by running for 256 yards in a victory over Bama.

The rivalry just might be the most heated in all of college football. Even from the first time Alabama and Auburn played, on February 22, 1893, there were disagreements. They argued over whether the game should be counted toward the 1892 season or the 1893 season.

Alabama scored its first victory over Auburn in 1894. The score was 18–0. Fuzzy Woodruff, a noted college football historian, wrote about that 1894 game:

> *Poor, puny Alabama had lost to Auburn the past two seasons, and Auburn's machine was far better this year. A remarkable crowd of 4,000 was at Riverside Park in Montgomery, an old state fair grounds field that was within a mile of a dirt track used for trotting horses.*
>
> *On the far side of the field were the high seated traps and low slung victories, the fashionable equipages of the day, and each conveyance was gay*

with colors and pretty femininity. The entire student bodies of both schools had made the journey to Montgomery and all the young men wore their hair in the exaggerated chrysanthemum shape that was then the mode.

Before the game the first charge of using ringers was made. Auburn charged Alabama was to use two players especially imported from the University of North Carolina for the game. If so, it was never proven because they didn't play. Collecting tickets and handling water buckets was a fellow named Champ Pickens, who promoted Alabama's trip to the Pacific Coast 30 years later.

From the start of the game, it was apparent that Auburn, despite its vaunted strength in the line, had nothing that could match the fury of the Alabama forwards. The attack was led by Jim Shelley, the halfback who repeatedly crashed over Frank Cahalan's tackle to lead an 18–0 victory.

Auburn and Alabama stopped playing after the 1907 game (covered elsewhere in this book). But the two student government presidents of the universities met in Birmingham in 1948 and actually buried a hatchet, a gesture meant to convey goodwill between the programs. Alabama beat Auburn in that 1948 game, 55-0.

After Bear Bryant arrived at Alabama in 1958, the rivalry picked up steam. Bryant and Auburn's Ralph "Shug" Jordan went at each other eighteen times between 1958 and Jordan's last year, 1975. Jordan was unlucky in that Alabama was the best program in the nation in the 1960s and '70s. He did win five games against Alabama in his matchups with Bear, but he lost thirteen times. Coach Jordan had beaten Alabama four straight times from 1954 to 1957 before Coach Bryant arrived.

Shug Jordan deserves full credit for his outstanding success at Auburn from 1951 to 1975, winning 175 games and the 1957 national championship. Jordan was known not only for his coaching success at Auburn but also for his character.

A story goes that Bear Bryant and Shug Jordan were fishing together once, and Jordan reminded Bryant that Alabama fans thought he could walk on water. Jordan told Bryant that he should try it. Bryant did and instantly sank. As Bryant swam to the side of the boat and reached up to Jordan for help, Bryant said, "Shug, promise me you won't tell the Alabama fans I can't walk on water."

Jordan replied, "All right, Bear. Just as long as you promise not to tell the Auburn fans I helped you back up."

Of course, Coach Bryant didn't mind needling Auburn a little bit, such as when he said, "I'd rather beat that cow college on the other side of the state" more than any other school. He must have been happy a lot, then, as he won nineteen and lost six against Auburn in his twenty-five years at Alabama.

4

110–0

Now, when you get whipped 110–0 in football, or any sport for that matter, one thing is pretty clear: you are downright sorry. That was the case on September 30, 1922, when Alabama beat Marion 110–0 in Tuscaloosa. Alabama was a decent team in 1922 under Coach Xen Scott. It finished 6-3 and had a huge win over Penn that garnered a lot of national attention. But when you beat a team by such a score, let's be honest, for the Tide players, practice against themselves would have been tougher.

Marion Institute, now Marion Military Institute, in Marion, Alabama, played Alabama nine times between 1902 and 1922. This is hard to believe, but in those nine games, Marion never scored, while Alabama piled up 482 points. It was 81–0 in 1902, 61–0 in 1919, 55–0 in 1921 and so forth.

A report of the Marion game in 1922 went like this:

> The stands were treated to thrill after thrill as one Bama man after another broke loose and ran for a touchdown. Although hopelessly beaten, the Marion Cadets had their old fighting spirit to the end. The sensation of the evening was a run from kickoff to touchdown by Alabama's Oliver. He received the ball on the 20 yard line and with beautiful interference he ran 80 yards for a touchdown. In the line, the work of Cooper, Compton, Propst, and Clemens was very noticeable, and the Cadets were unable to gain, not making a single first down. Pooley Hubert also showed up well in the placement kick for extra point after touchdown, five out of six attempts. The Marion team was too light to cope with their beefier opponents. They had no chance to uncork any of their plays.

Almost without question, this win over Marion in 1922 stands alone as the most dominating win in Alabama history. But no doubt Alabama fans savor more the 55–0 win over Auburn in 1948 or even the 42–14 whipping in 2011—in Auburn, no less.

5

"SOUTHERN ELEVEN HAND PENN FIRST DEFEAT OF YEAR"

The headline in 1922 celebrated a win over national power Penn. Of course, the "Southern Eleven" were the boys from Tuscaloosa, who shocked the nation by traveling north to beat Penn at Franklin Field in Pennsylvania.

Penn pretty much considered the Alabama contest no more than a practice game, according to reports of the time. But L.O. Wesley kicked a field goal to put Alabama ahead 3–0 in the first half. After a touchdown by Penn, the score was 7–3 at halftime, but Alabama scored on a short touchdown run in the third quarter for the final 9–7 score.

The year 1922 was an era when southern schools were considered inferior in their knowledge of football and in their ability to play the game. But this win over Penn gave football teams from the South hope that things were improving and they could compete with teams from other parts of the country.

Charles Bernier, Alabama athletic director, deserves some credit for the win. A side trip was arranged by Bernier for the team to stop in Washington, D.C., on the way to Philadelphia to see Navy play Penn State. After watching the game, most of the players on Alabama's team gained confidence that they could play with northern teams. "These players up here are just human, like us. We can beat them," one Tide player remarked.

Another tactic that went well for Alabama was revealed by Al Clemens of the Tide. Penn had an All-American lineman named Thurman:

> We were going to pretend Thurman didn't exist. Our game plan was to run right at him. During the game, between the plays, we'd say, "Where's Thurman? We thought he was supposed to be some All-American. When's he going to show up?" We got him so upset, he slugged our fullback W.C. Baty. The referee put him out of the game. He was a great player, and we had the game won after that.

6

THERE WAS A BEAR IN TUSCALOOSA BEFORE BEAR BRYANT

Wallace Wade was born in Trenton, Tennessee, on June 15, 1892. Born and raised on a farm, Wade would eventually retire as a cattle farmer. In between these years, Wallace Wade attained recognition and respect nationwide as one of the greatest college football coaches who ever lived.

At every stop of his football career, Wade attained outstanding success. While playing for Brown University, Wade's team competed in the 1916 Rose Bowl. After graduating from Brown, Wade became head coach at Fitzgerald and Clark School in Tullahoma, Tennessee. While at Fitzgerald and Clark School for two seasons, Wade's teams won sixteen games and lost only three; his team also won the Tennessee state high school championship in 1920.

In 1921, Wade was hired as an assistant coach to Dan McGugin at Vanderbilt. During Wade's two years at Vanderbilt, the football team won two Southern Conference championships and never lost a game, going 15-0-2.

In 1923, the University of Alabama hired Wade as its head football coach. This hire established Alabama as a storied name in national football circles. During Wade's eight years as coach of the Crimson Tide, Alabama won sixty-one games against only thirteen losses. The first four conference championships and first three national titles in Alabama football history were won under Wade.

In the year 1925, Wade truly established Alabama as a national football power. Finishing the regular season 9-0, the Crimson Tide outscored its opponents 277–7. After the season, Alabama was invited to play in the Rose Bowl. Up to 1925, football in the South was considered mediocre

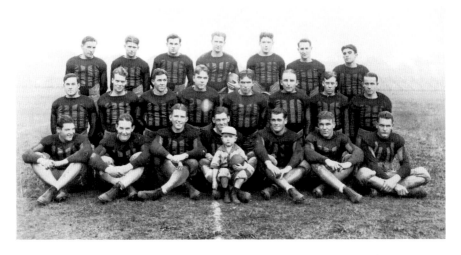

In 1925, Alabama went undefeated at 10-0, beating Washington in the 1926 Rose Bowl. Many college football historians consider this to be the most important game in southern football history, as the upset win showed the nation that southern football could compete— and win—against teams around the nation. This team won the first national title in Alabama football history. *Courtesy of Hoole Library, University of Alabama.*

compared to other parts of the country. A stigma of inferiority was the general perception of southern teams; not only that, but the South also had a historical legacy of military defeat, poverty and cultural alienation from the rest of America.

Alabama's opponent for the January 1, 1926 Rose Bowl was the University of Washington. Alabama was a heavy underdog but won 20–19. The *Atlanta Georgian* newspaper called the win "the greatest victory for the South since the first battle of Bull Run." Many college football historians agree that this victory by Wade's Alabama team was the most important game in southern football history.

But Wade was not through at Alabama, not by a long shot. The Crimson Tide repeated as national champions the next year and would win another national title in 1930. In 1930, Alabama did not just beat its opponents but ran roughshod over them, outscoring its nine regular-season opponents 247–13. The Crimson Tide then beat Washington State 24–0 in the Rose Bowl.

His players often called Coach Wade the "Bear," but only when he was not around. Coach Wade could be ornery, and his practices were legendary for their toughness.

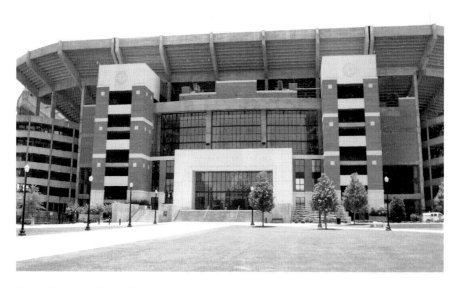

Shown is Bryant-Denny Stadium as it looks today. *Courtesy of Beth Bowling.*

Wallace Wade became head coach of Duke University in 1931. But Wade's impact on the Alabama football program will forever be felt. He won over 80 percent of his games with the Crimson Tide, won the first four conference championships in the history of Alabama football and won the school's first three national championships. Bear Bryant fell in love with Wade's teams while growing up in Arkansas and came to Tuscaloosa to play football largely because of what Wade had accomplished. Denny Stadium, now Bryant-Denny Stadium, was started with funds from Wade's 1926 and 1927 Rose Bowl teams. Wade also picked his successor, Frank Thomas, who went on to coaching greatness at Alabama.

Success continued to follow Wade in his coaching career at Duke. He won 110 games, with only 36 losses, in his sixteen years leading the Blue Devils. Wade took Duke to two Rose Bowl games, and his 1938 team not only went unbeaten during the regular season, but also not one of its nine opponents scored a point.

Coach Wade's Duke team lost to Oregon State in 1942 in the Rose Bowl. This was a historic game as it was played in Durham, North Carolina, home of Duke University, because of the Japanese attack of Pearl Harbor on December 7, 1941, precipitating a ban of sporting events on the West Coast.

Shortly after the 1942 Rose Bowl, Wade resigned as Duke coach to volunteer for the army. This man who was recognized as one of the greatest coaches in the nation, who had appeared on the cover of *Time* magazine in 1937 and who had

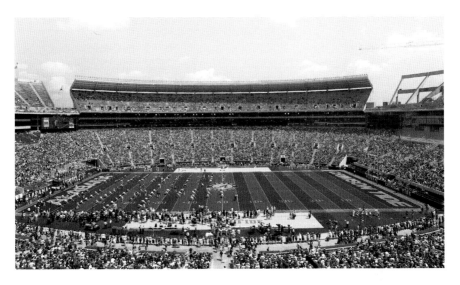

The stands at Bryant Denny Stadium are starting to fill up before a game, and by kickoff, over 100,000 fans will be in attendance. *Photograph by Carol M. Highsmith from the Library of Congress George F. Landegger Alabama Collection. Courtesy of Carol M. Highsmith.*

a phenomenal record of 146 wins and only 32 losses up to 1942, gave up his love of football to serve his country in war at the age of forty-nine. But as Wade said, speaking of his players, "My boys were going in, and I felt like we should stay together as a team; we were just participating in a different battle."

Wade was eventually promoted to lieutenant colonel and led the 272^{nd} Field Artillery Battalion in the Battle of Normandy, the Battle of the Bulge and the 9^{th} Army drive through Germany. The French government awarded Wade the Croix de Guerre with Palm, and he received a Bronze Star and four battle stars.

Lieutenant Colonel Wade came back to Duke in 1946 after World War II to become Coach Wade again, agreeing to lead the Blue Devils on the gridiron once more. Wade coached Duke through the 1950 season and then was appointed commissioner of the Southern Conference, a position he held to 1960.

Wallace Wade Drive now runs alongside Bryant-Denny Stadium at the University of Alabama, and a huge statue of Coach Wade was erected in front of the stadium in 2007. Wallace Wade Stadium is now the home football field for Duke University, and Coach Wade is enshrined in the College Football Hall of Fame, receiving his just due as one of the greatest football coaches who ever lived.

7

"DIXIE ACCLAIMS HER HEROES"

Hardly anyone gave Alabama much of a chance against the Washington Huskies. Even though the Crimson Tide under Wallace Wade had finished the 1925 regular season unbeaten at 9-0, football in the South was considered inferior to that in other parts of the country. Ed Danforth of the *Atlanta Georgian* thought that perhaps "Alabama would travel all the way out there, get spanked and come home with a good record dented." Disdain for Alabama was shown in a description of the Tide team as "swamp students," and the famous Will Rogers labeled the team from Tuscaloosa "Tusca-losers."

Washington came into the 1926 Rose Bowl undefeated. Since 1922, the Huskies were a combined 34-3 under Coach Enoch Bagshaw. This team had tradition, and plenty of it. From 1908 to 1916, Washington went 58-0-3 under Gil Dobie. The 1926 team was led by All-American halfback George "Wildcat" Wilson, who had already turned down a then incredible $3,000 salary to turn pro.

Washington was such a big favorite to defeat Alabama because football in the South was just not respected; it was catching up with the rest of the country, but a stigma of inferiority was the general perception. As the train carrying Alabama's team left Tuscaloosa on December 19, the hopes of an entire region traveled with it. President Denny realized what they were up against, saying:

Our team will strive to represent worthily our great commonwealth and our great section. We recognize the difficulties and the handicaps of a long

trip to the distant region in which we shall be strangers, both to the climate and to the people. We recognize we shall meet the champions of the Pacific Coast, one of the greatest teams in the country, one of the most powerful America has produced. Such is the colossal task to which our boys have set their hands. Win or lose, this trip means more widespread and sustained publicity for Alabama than any recent event in the history of the state.

Coach Wade took no chances. He ordered that drums of Alabama drinking water be brought on the train to decrease the possibility of water-borne disease. He had learned this from his old Brown coach, Edward Robinson, when Brown played in the 1916 Rose Bowl. Also, as the team journeyed across the vast expanse of America, Wade held briefings with his team twice a day on the game plan and scouting reports. Zipp Newman, with the team, wrote, "There isn't a player on the train who can't tell you the name, weight, disposition, and a few other little things about every player eligible on the Washington team." Wade had told his team before departing, "Now, this is to be a trip to go win a football game. We're not going out there to make an appearance and enjoy the scenery. I want your minds on Washington." Knowing full well the value of physical conditioning, Wade had his players get off at every stop to do some running and limbering-up exercises. The team was allowed to stop at the Grand Canyon for a tour. In Williams, Arizona, the team held a practice at a local high school field.

The Alabama squad arrived in Pasadena on Christmas Eve, but Coach Wade was in no mood to be Santa Claus. His Christmas present to his team was a long, hard practice, with talk of Huskies instead of reindeer. Coach Wade was not the complete Scrooge, allowing sightseeing tours for a couple days in between practices. But just days before the game, he had had enough. "In order to get in the right mental attitude, no more entertainment will be indulged in," he declared on December 28.

Pooley Hubert and Johnny Mack Brown seemed to garner a large part of the press's attention. In fact, Newman wrote, "Hubert and Mack Brown will have enough experience posing for the cameramen to enter the movies after their stay here." Little did Newman know that Brown would become one of the premier cowboy movie stars of the 1930s and '40s. Brown's great personality and striking good looks helped his entrance into celebrity status. Interestingly, Washington had a future movie star as well. Herman Brix, who would win a silver medal in the shot put at the 1928 Olympics, played the title role in *The New Adventures of Tarzan* in 1935. Using the stage name of Bruce Bennett, Brix appeared in over eighty feature films.

As the game neared, the press continued to advertise the game as one of the largest intersectional conflicts since the Civil War. Alabama started to feel the pressure of not just winning the game but also representing the entire South. Washington was cast into the role of the Yankees, even though its ancestors had fought more Indians than Confederates. Coach Wade was not opposed to this territorial pride-building, as he realized it would probably serve only to further motivate his "southern boys." In later years, he would sometimes refer to his old Brown teammates as "Yankee boys," but in a teasing, friendly way.

As New Year's Day 1926 arrived, crowds of Alabamians gathered in theater auditoriums and in offices to follow the play-by-play account of the game over a special Associated Press wire. The Grand Theater in Montgomery was filled to standing room capacity, and hundreds more could not get in. The police decided to rope off a block of Dexter Avenue, the main downtown Montgomery street, for those who stood outside in cold winter weather to get reports of the game. There were similar gatherings across Alabama and throughout much of the South. Huge throngs of people did this despite the fact that several radio stations in Alabama were broadcasting a re-creation of the same wire transmissions, but they chose to gather to show their collective support for "their boys." At Auburn University, students packed the campus auditorium to cheer on their rivals.

The game started badly for Alabama. On Alabama's first possession, Wilson stopped them cold. The Tide marched to Washington's fifteen-yard line. On the next play, Wilson hit Johnny Mack Brown and threw him for a two-yard loss. On the very next down, Wilson crashed through the offensive line to sack Emile Barnes for an eight-yard loss. Wilson, whom Winslett had described as looking like "a bale of cotton" because of his huge size, then intercepted an Alabama pass. Patton scored a touchdown for the Huskies, but the point after was missed.

Early in the second quarter, Wilson threw a twenty-yard touchdown pass to Cole for a 12–0 lead. Wilson was unstoppable on offense and defense. The Alabama players were stunned at the speed, power and ferocious spirit of this man called "Wildcat." The Huskies had scored two touchdowns in less than a half, compared to only one touchdown scored on the Tide in nine regular season games all year. It looked as though the prognosticators had been correct: West Coast football was still very much superior to the brand of football played in the South.

Not only was Wilson dominating play, but he also decided to get a little dirty with Alabama. On a tackle against Johnny Mack Brown, Wilson

viciously twisted Brown's leg well after he had him on the ground. This unnecessary roughness can be seen clearly on game film. This was a mistake, as the Alabama teammates were tremendously loyal to one another, and to see Wilson try to injure one of their own literally incensed them. This tackle, combined with an outburst from their leader, Pooley Hubert, really got up their fighting spirit. Hubert was so disgusted with his teammates' play at one point in the first half that he called all of them over during a timeout and screamed, "All right, what the hell's going on around here?!"

Back in Alabama and across the South, sad crowds had not given up hope, but prospects certainly did not look good. The crowd on Dexter Avenue in Montgomery walked about, their hopes seemingly dashed. In the front window of the Rosemont Gardens Florist Shop, some of the fans looked at the Alabama team photograph, which was displayed inside a horseshoe-shaped arrangement of red roses. Meanwhile, in Court Square of Montgomery, where a wild celebration had taken place sixty-five years earlier when news of the fall of Fort Sumter had come, a stockpile of fireworks awaited the big display that had been so hoped for after the boys of Alabama defeated the "Yankees" of Washington. Across the South, despondent fans worried that what most people around the country had predicted was about to come true and that Alabama had not deserved to be invited to the prestigious Rose Bowl.

Back in the clubhouse at the Rose Bowl, the Crimson Tide players were getting "riled up," to use an old expression. They were "mad as hell," according to Coach Wade, over the fact that they had played so poorly in the first half. They were upset at Wilson for his rough handling of Brown, and they felt they had let their field general, Hubert, down. They had seen the fire in Hubert's eyes, the man Wade, in retirement, called "the best field general I ever coached; he could lead men like no other player I ever had."

The team gathered together expecting Coach Wade, Coach Crisp and Coach Cohen to "lay into us," as one player put it. Wade knew his team, knew the pride it had in itself. He knew their faces, and what he saw pleased him to no end. There was no look of despondency, there were no drooping shoulders and they did not look like a team that was literally being dominated. Instead, there was a tensing of muscles, a ramrod posture and a look in the eyes that had a fierceness about it. Wade, at that point, calmly made an adjustment to his lineup that would have a profound impact on the game. Most of Washington's big-yardage plays in the first half had been made through Alabama's ends. He inserted two heavier players at these spots for the second half, and this move dramatically cut down the running attack for the Huskies.

Abraham Maslow, a famous psychologist, coined the term "fight or flight" for people who are under a lot of stress. Wade, from looking at his boys, knew that his team, every single one of them, was now confronted with the choice of fighting or quitting, and he had absolutely no doubt they had chosen. To put them over the edge, he walked in and said in a rather low voice, "They told me boys from the South would fight." Then he left. The game was now over; those "damn Yankees" were about to experience the beating of their careers.

Another change Wade made at halftime was to tell Hubert to start running the ball more. On the Tide's first possession of the second half, Hubert exploded up the middle for twenty-seven yards. He then carried the ball four more times in a row, plunging over the Washington goal from the one-yard line. Five carries in a row for a total gain of forty-two yards, on runs of twenty-seven, ten, one, three and one, by Pooley made the score 12–6. After the point after, it was 12–7. On Alabama's next possession, the ball was snapped to Grant Gillis, who threw the ball at least fifty yards to Johnny Mack Brown, who made a spectacular catch and scored on the sixty-three-yard play. With the PAT, it was now Alabama 14, Washington 12.

Pandemonium started to break out back home in Tuscaloosa, Montgomery, Birmingham, Dothan, Auburn, Meridian (hometown of Hubert), Atlanta, New Orleans and other towns across the South. But the game was far from over. The Tide held on defense. George Wilson was on the bench, having been knocked unconscious on an earlier play, delivered courtesy of the enraged Alabama players over the tackle Wilson had put on Brown. With the ball, and up by two, the Crimson Tide went to the air again, this time with Hubert passing to Brown, who caught the ball over his shoulder, sidestepped to get by one tackler and then stiff-armed another to score. The point after was missed, but now Alabama was up 20–12. Alabama had erupted for three touchdowns in seven minutes of play in an era when offensive explosions were not the norm. But plenty of time remained, and Coach Enoch Bagshaw of Washington and his Huskies had no quit in them. A still dazed "Wildcat" Wilson came back in the game and scored a touchdown in the fourth quarter to make it 20–19. Time still remained, and the hopes of the South were in the hands of the boys from Alabama.

With Wilson running and passing, the Huskies drove deep into Alabama territory late in the game. Brown made a key tackle of Wilson on this drive, and an interception ended the hopes for a Washington comeback and lifted the hopes and spirits of southern football fans everywhere. This victory put Alabama on the national football map. Alabama had its first national

championship, and many would follow. The victory today is known by most scholars and historians of the game as the biggest victory in the history of southern college football.

Even the fans of the Rose Bowl, who had begun the game firmly in favor of the West Coast Huskies, had gradually seemed to shift their allegiance to the underdog Alabama team. By the time the game ended, there was a thunderous roar for the Tide. Fans actually ran on the field to get close to this team that had proven all the experts wrong. They knew they had witnessed and had been part of something historic. David had truly slain Goliath once again. As "Alabama Wins" flashed across the wires back in Alabama, pandemonium erupted in the packed streets, theaters, auditoriums and offices across the state. Southern honor had been vindicated.

All the way along the route home, people gathered to shout and cheer for the Crimson Tide. There was a huge celebration in New Orleans, led by William Little, the man who had started Alabama football back in 1892. Large iced cakes and dressed turkeys were presented to the team. Speeches followed, and a band played. "Hip, hip, hurrahs!" for the players and coaches never seemed to stop. The train stopped in the Alabama towns of York, Livingston, Akron and Boligee—more speeches and bands, more gifts as tokens of appreciation for the great victory.

All of Tuscaloosa turned out to meet the team when its train arrived at the depot, and people from around the state came. Some fans even climbed up on the depot's roof to get a better look. It was with much difficulty that a passageway was made for the team to reach the decorated wagons waiting to pull them through the crowded streets of Tuscaloosa. The Million Dollar Band paraded ahead of the wagons to the intersection of Broad and Greensboro Avenues, where Governor Brandon voiced an eloquent welcome home and thank-you on behalf of the state. So many people came to see the team that it took an hour to inch along the three-quarter-mile route from the depot to downtown.

One speaker told the happy gathering, "When the band plays 'Dixie' over this team, it can whip eleven Red Granges." Wade and Denny made speeches also, and particularly loud cheers were given to them, Hubert and Brown. The parade formed again and proceeded to the university, where more speeches, band playing and general merriment ensued. The Tuscaloosa Chamber of Commerce presented each player and coach with gold watches and other gifts.

Praise flowed in for the Crimson Tide from all over the country. The *Birmingham News* summed up the victory this way:

For all the last stands, all the lost causes and sacrifices in vain, the South had a heart and a tradition. But the South had a new tradition for something else. It was for survival and victory. It had come from the football field. It had come from those mighty afternoons in the Rose Bowl in Pasadena when Alabama's Crimson Tide had rolled to glory. The South had come by way of football to think in terms of causes won, not lost.

The *Atlanta Georgian* called the win "the greatest victory for the South since the first battle of Bull Run." The *Atlanta Journal* carried the headline "Dixie Acclaims Her Heroes." The *Birmingham News* claimed that words on newsprint could not do justice to the "miracle at the Rose Bowl."

The many references to "a victory for the South" were in large part due to the still-felt sting of defeat in the Civil War and the effects of Reconstruction. Many southerners held the belief that one Confederate soldier was worth several Yankees in battle, and Alabama's victory helped to validate that opinion. Much of the South in 1926 still held special holidays and celebrations to commemorate the war, and many towns had Confederate monuments displayed proudly in courthouse squares. Leaders in Tuscaloosa had even decorated the city's lampposts with American, Alabaman and Confederate flags for the welcome home ceremony for the Tide team.

But this victory did much more than just lift spirits. It lifted the profile of the South, especially Alabama, across the nation as a region that was on the move, a section of America that was catching up—an equal. A speaker introduced Wallace Wade sometime after the victory as "a man who has advertised Alabama more in the past three years than any other man in the past fifty years." Zipp Newman perhaps summed up the importance of the victory best, writing, "No victory in football ever changed the destiny of one section of the country like Alabama's furious seven-minute comeback against Washington."

Another footnote to the 1926 Rose Bowl is that it was the first football game Bear Bryant ever listened to. The Crimson Tide of Alabama remained in young Bryant's heart from that moment on. He recalled many years later, "I never imagined anything could be that exciting. I still didn't have much of an idea what football was, but after listening to that game, I had it in my mind that what I wanted to do with my life was to go to Alabama and play in the Rose Bowl."

"Boys, We're Going to Win the Damn Championship This Year"

Alabama 271, Opponents 13

America had suffered depressions before, but none hit so hard as the one of the 1930s. Banks failed, jobs were hard to find, people lost their homes, savings accounts were wiped out and bread lines appeared with hundreds of ragged and hungry people waiting for food.

The Great Depression certainly battered Alabama as well. Many people in the state had been poor before 1930, and they were used to hard times. As one said, "Hard times don't worry me. I was broke when it first started out." People in the middle and upper classes noticed the most drastic changes.

More bad news rocked the state of Alabama when Wallace Wade announced his resignation, becoming effective after the 1930 season. Wade was leaving to become head coach at Duke in 1931. Duke University, located in Durham, North Carolina, had enticed Wade with what was in 1930 one of the highest salaries of any coach in the country: $12,500 a year, plus a percentage of gate receipts. Denny paid tribute to Wade, saying, "Duke University is fortunate to obtain a coach of Wallace Wade's ability. It is with deep regret that I learn Coach Wade is going to leave us after the 1930 season. He has made Alabama not only a great coach but a great leader of young men."

Wade's resignation was a complete surprise to most Alabama fans, students, alumni and football fans nationwide, especially in the South. There is no doubt that the caliber of play of Wade's teams had dropped in 1927, 1928 and 1929, when the combined record was 17-10-1. The 1929 team was 6-3. There was some unrest expressed by people associated with the program. For sure, Coach Wade heard some of this, and there is also no

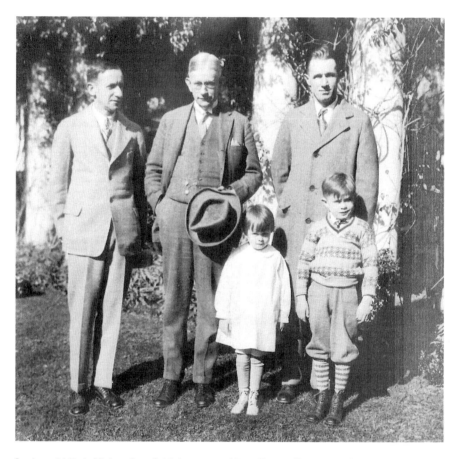

In the middle is University of Alabama president George Denny, and on the right is Wallace Wade, Alabama football coach from 1923 to 1930. The two children are Coach Wade's—Wallace Jr. and Frances. Bryant-Denny Stadium is named for Bear Bryant and Dr. Denny. *Courtesy of Lewis Bowling.*

doubt that it did not please him, especially after winning two national titles and having a record of 51-13-3 after the completion of the 1929 season. Wade could take criticism, and he was tremendously confident in his ability to get Alabama back in contention for national titles. But he was human, too, and after tasting victory on a national scale, Alabama fans were not satisfied with 6-3 seasons. They voiced their opinions.

There is no question that Coach Wade's job was never in jeopardy, as President Denny knew what kind of coach he had, as evidenced by the offer of a new five-year contract extension in 1930. Salary may have played a part, but Wade's salary of $8,000 at Alabama put him near the top of the scale. Another

factor was that Wade had truly enjoyed his experience at Vanderbilt, a private institution like Duke, and Wade felt that it might be a good opportunity to build another program, much like he had done at Alabama.

Was there a rift between Wade and his boss, Denny? The two men respected each other but were not the best of friends. Denny knew Wade could coach football like few men ever had, and Wade knew that Denny was a good leader and administrator who had built the university into a nationally respected institution. At the same time, Wade knew that football and athletics were the parts of university life that he was suited for, and he wanted to have pretty much total control of his programs. Denny enjoyed attending practices and staying on top of things in all university matters, including athletics—which as president was his prerogative and, some would say, his job.

Later in life, Wade was asked about his relationship with Denny. He replied that "President Denny built the University of Alabama up from almost nothing, and he deserves credit for that. We both had jobs to do at Alabama, and I feel the university benefited from my football teams and his leadership. It was just time for me to move on."

One important sign of respect Denny showed to Wade was that he accepted Wade's choice of successor, Frank Thomas.

Denny told Wade to go ahead and make the first contact with Thomas. This happened in the spring and summer of 1930 and with the certainty that Wade would honor the last year of his contract and coach through the 1930 season. Wade was a man who throughout his life tried his utmost to do what was right, and he would never have considered breaking his contract with Alabama.

Calling Thomas, Wade set up a meeting between the two of them at a track meet in Birmingham. Thomas agreed, not having any idea that Wade had resigned. He agreed because he knew Wade from his assistant coaching job at Georgia, where he had played Alabama, and he agreed because the name Wallace Wade had nationwide respect, perhaps second to none other than the great Rockne.

Meeting underneath the west stands of Legion Field as rain was pouring down, Wade got right to the point, as was his custom. "Well, I've done it, Frank," said Wade. "I've resigned to become head coach at Duke University, and I have recommended you to succeed me at Alabama." Thomas was stunned. Wade continued to tell Thomas what a good situation Alabama would be for him, but Thomas did not need much convincing.

"You'll hear from Alabama within the next few days," Wade said before departing. Sure enough, Thomas was called to meet with Denny in

Birmingham on July 15. Borden Burr, an influential Alabama alumnus, and Ed Camp, an Atlanta newspaperman, also attended this meeting in which Thomas was officially offered the job.

After the contract was signed, Denny told Thomas, in his own unique way, that winning football games at Alabama was important:

> *Mr. Thomas, now that you have accepted our proposition, I will give you the benefit of my views based on many years of observation. It is my conviction that material is 90 percent, coaching ability 10 percent. I desire further to say that you will be provided with the 90 percent and that you will be held to strict accounting for delivering the remaining 10 percent.*

Upon leaving the meeting, Thomas commented to Camp, "Those were the hardest and coldest words I ever heard. Do you reckon his figures are right?"

"I think the proportion was considerably off," said Camp, "but there is no doubt the good doctor means what he said."

Lawrence Perry, a well-known newspaperman of the time, wrote the following shortly after hearing about the resignation:

> *When he goes he will leave a soundly organized football system at Tuscaloosa. Material has been gravitating toward Alabama for so long as to make the trend a fixed habit and Wade's successor will not be worried by lack of cannon fodder. Approximately 4,000 students are now enrolled at the institution and they hail from most of the states of the union, and part of that is because of the national acclaim the football team under Wade has garnered.*

Wade also recommended that Hank Crisp succeed him as athletic director, and this was accepted also. Wade said that "Crisp is a great man for the job, the best man anywhere, and I do not think the university could have made a better choice had it searched the entire nation."

Wade hired two former players, Herschel Caldwell and Dumpy Hagler, to immediately go to Duke and serve as assistants under the coach at Duke, James DeHart. In this way, Caldwell and Hagler could start to implement the Wade system of football, and when Wade himself arrived in 1931, football matters would be much further along. To his staff at Alabama was added Paul Burnum, who had been the coach at Tuscaloosa High School. The Black Bears had established themselves as a national power in the high school ranks, winning seventy games against only two losses and two ties in the years leading up to 1930. The Black Bears had defeated teams from

around the country, including Senn High of Chicago; Lakeland, Florida; McKinley Tech of Washington, D.C.; and University City High from St. Louis. One of the players was John Henry Suther, a star player at Tuscaloosa High and at the University of Alabama. Former Wade player Al Clemens replaced Burnum at Tuscaloosa High. Wade had signed players from Burnum's teams to play for him for years, and Burnum had attended Wade's football coaching schools, so they had a good relationship.

Also added to the Tide staff for 1930 was Orville Hewitt, better known as "Tiny," although Orville was anything but tiny. A local reporter described him in this way: "When Tiny was at the height of his football career his weight was around 200 pounds, but since leaving school he has gained and now is quite rotund. He is a jolly fellow and has a pleasing personality." Tiny had made several All-American teams playing at Pittsburgh before going to West Point and becoming a second lieutenant.

As the University of Alabama made plans to celebrate its 100th anniversary in 1931, Wallace Wade and the Crimson Tide football team readied for the 1930 season. Wade was absolutely determined to have a successful season. He called his players together on the first day of practice and said, "Boys, we're going to win the damn championship this year. Now, those of you who want to be part of it, let's get going. If there is anybody here that is not 100 percent committed, leave now." No one left.

The backfield for 1930 equaled any in the country, with Johnny Cain, John Henry Suther and Monk Campbell. With Fred Sington, Frank Howard, Charles Clement and Carney Laslie at tackle and guard spots, the line looked to be exceptional. For sure, this was going to be a team to be reckoned with.

Zipp Newman thought the Tide would be good, writing that "the Crimson Tide will be a most feared opponent. A team dreaded more than the plague. And why? Because Wade will have another bone-crushing line and a squad that will outfight its weight in wildcats."

There is absolutely no question that Wade, possessed of fierce pride and determination, wanted to go out with a bang. He had built Alabama into a power, and he wanted to be sure he left the program at the top. Preseason practices took on a higher intensity than any seen in his previous years, and Wade's practices had always been characterized by hard-nosed, intense effort. But Wade drove his players even harder than before, and the results of this preparation would take the college football world in 1930 by storm.

Alabama opened the year with an easy 43–0 win over Howard in Tuscaloosa. In this game, Hugh Miller, who is featured in another chapter in this book, drop-kicked a field goal from forty yards out for three points.

Big Al, the Crimson Tide's mascot. *Photograph by Carol M. Highsmith from the Library of Congress George F. Landegger Alabama Collection. Courtesy of Carol M. Highsmith.*

Alabama stayed home on Denny Field for its next game and blasted Ole Miss 64–0. It was during the Mississippi game that Alabama picked up the elephant as its mascot. Wade had held his regulars out to start the game and then sent in his rather large first team. One of the spectators shouted, "Here come the horses!" and another fan exclaimed, "Those aren't horses, they're elephants!" An Atlanta sportswriter heard this, and the new elephant mascot was born.

On October 11, Alabama beat Sewanee 25–0 in Birmingham to run its record to 3-0. Powerful Tennessee came to Tuscaloosa on October 18 for what may have been Alabama's biggest test of the year. An overflow crowd of eighteen thousand fans jammed Denny Stadium on Homecoming Day. General Neyland's Volunteers had not lost a game since November 13, 1926, a stretch of thirty-three games without a loss. Tennessee—like Alabama, 3-0 coming into this game—had outscored its three opponents 99–0. After this game against Alabama, which Tennessee lost, the Volunteers would not lose again until 1933, and it would be to Wallace Wade and his Duke Blue Devils.

Wade used a psychological ploy against Tennessee by starting his second-string team, the same tactic he would use in most games in 1930. Wade had a

strong belief that, at the very least, his second team could hold the opponent scoreless, and then, when he sent in his first team, it would be demoralizing to whomever they were playing. Against Tennessee, he kept his first team off the field until late in the first quarter, when the Volunteers began a sustained drive. When they reached Alabama's twenty-eight-yard line, the regulars came in, and behind the inspired play of Fred Sington, Monk Campbell and Charles Clement on defense, they kept Tennessee out of the end zone. From their own ten-yard line, where Tennessee had run out of downs, Alabama ran the ball straight down the field on eleven straight plays, with Johnny Cain bursting off tackle for fourteen yards to end the scoring drive. In the second quarter, Alabama gained possession on the Volunteer forty-yard line. John Henry Suther, the Tuscaloosa High product, ran for nine yards and then sprinted the remaining thirty-one for a 12–0 lead at the half.

In the third quarter, with the home crowd sensing an upset win for the Tide, Alabama recovered a fumbled punt and had the ball on Tennessee's twelve-yard line. Monk Campbell scored, and it was 18–0, Alabama. The huge Homecoming Day crowd was in pandemonium. In the last quarter, Bobby Dodd of the Volunteers led them on a scoring drive to make it 18–6, but the Tide held on for its most important win since the 1926 Rose Bowl.

The next week, Alabama beat Vanderbilt 12–7 in Birmingham. Vanderbilt was, as usual, one of the top teams in the South in 1930, posting an 8-2 record, with a win at Minnesota and shutting out Auburn 27–0. So with key wins over Tennessee and Vanderbilt, the Tide was 5-0. The seven points Vanderbilt scored would be the last points registered against Wade's defense the rest of the year. Wade stuck with his favored 6-2-2-1 alignment for most of that season: six linemen played up front, behind them were what are today called linebackers and then three played the defensive backfield, with one of those back deep.

November 1 found Alabama in Lexington before twenty-two thousand fans. The Tide beat the Wildcats 19–0. The pass was revealed in this game when Suther caught a forty-four-yard touchdown pass from Jimmy Moore. Alabama served as the opponent for Florida on November 8 as the Gators dedicated their new stadium. J.B. "Ears" Whitworth kicked two points after touchdown in this game and played well at his tackle position.

After posting a record of 22-27-2 from 1950 to 1954 as head coach at Oklahoma State, Whitworth would go on to become Alabama's head football coach at the start of the 1955 season, and his tenure did not turn out well. (That may qualify as one of the biggest understatements Alabama football fans will ever read.) Alabama went 0-10 in 1955, even with Bart

Starr at quarterback. Whitworth had a record of 4-24-2 in his three years, and even worse, Auburn scored one hundred points to Alabama's seven in its three victories over Whitworth's Tide.

After his 1957 team went 2-7-1 and lost to Auburn 40–0 in the last game, Whitworth was let go. On December 3, 1957, Alabama signed Paul "Bear" Bryant to a contract, and Alabama would start winning like it never had. Upon announcing that he was leaving Texas A&M to come to Tuscaloosa, Bryant explained his reasoning in two words: "Mama called." Well, Coach Bryant did not disappoint "Mama," as he won 232 games at Alabama from 1958 to 1982, against only 46 losses and 9 ties, with six national championships and thirteen Southeastern Conference titles.

The Tigers of LSU came to Montgomery to play a Tide team that was 7-0. It was no contest, as Alabama won 33–0. A big dance was held in Coach Wade's honor after the game at the Standard Club in Montgomery; both teams attended. LSU was coached by Wade's former assistant at Alabama, Russ Cohen. Cohen would compile a record of 23-13-1 at LSU from 1928 to 1931, going 0-2 against Wade. Starting with Wade at Alabama in 1923 and being part of the national championship teams of 1926 and 1927, Cohen had been enthusiastically endorsed by Wade for a head coaching position. The two remained lifetime friends.

The last game of the regular season had Alabama in Birmingham against the Georgia Bulldogs. Georgia came into the game 6-1-1, with a big win earlier in the season over Yale at Yale. Georgia was coached by Harry Mehre. By the date of this game, November 27, Washington State had already been chosen to represent the West in the Rose Bowl, and the winner of the Alabama-Georgia game was the probable selection as the opponent. Two Washington State scouts sat in the stands and saw Alabama beat Georgia 13–0.

The game at Legion Field not only had the Rose Bowl on the line but also a Southern Conference championship and an undefeated record at stake in Alabama's case. Fans totaling twenty-nine thousand attended the game, and they saw Johnny Cain run for 118 yards and two touchdowns. J.B. Roberts Jr., a local reporter, was at the game, along with many newsmen. He wrote:

> *William Wallace Wade bid a dramatic adieu to the University of Alabama as his football eleven, the men who have learned all of the football that they know from him, swept a determined and inspired Georgia team aside to gain a 13 to 0 verdict. Alabama had outscored its opponents 247 to 13 for the nine regular season games. The atmosphere around Legion Field seemed to*

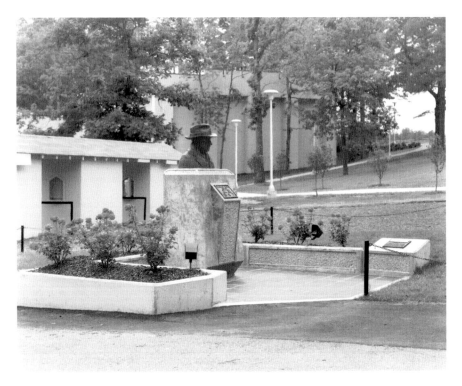

A bust of Wallace Wade at Duke University, where he coached after leaving Alabama in 1931. Coach Wade and Duke hosted the 1942 Rose Bowl, the only time the Rose Bowl was played outside the state of California. The rose bushes in the picture were sent from the Rose Bowl to commemorate the 1942 Rose Bowl. The stadium on the Duke campus is Wallace Wade Stadium. *Courtesy of Beth Bowling.*

breathe of an Alabama day, and the 29,000 gaping fans who wedged their way into every available space within the enclosure, had the feeling that the Tide was bound for glory. Just before the game began, and after Georgia had gained a distinct advantage by winning the toss and getting a stiff wind at their backs, Wallace Wade gathered his red-clad boys around him and with a quivering chin, spoke to them and asked them to give their very best. And the way Captain Clement, Freddie Sington, and the rest of Alabama's great crew slapped the departing leader on the back and shook his hand, made the issue practically certain to those who knew. Straight bucks and off tackle sweeps by Johnny Cain, Suther, and Campbell accounted for big yards. At halftime and at the end of the game, Coach Wade received the tribute of the witnessing thousands as mighty Wade, Wade, Wades resounded through Legion Field. Few men have ever been accorded the honor that was Mr. Wade's.

M.E. Nunn, also at the game, wrote:

> *The South as a whole owes a debt of gratitude to Wade for bringing national recognition to this section of the country. In the departure of Coach Wade for Duke at the end of the present season, the University of Alabama has lost a great coach, a builder of character, a teacher of ideals, and a man who has commanded the respect of students, fans, and sportsmen. When the whistle sounded ending the game against Georgia, the vast crowd rose and cheered long and loud for the man who had done so much for Alabama and southern football.*

The Rose Bowl invited Alabama to oppose Washington State on New Year's Day 1931. Washington State came into the 1931 Rose Bowl 9-0, having defeated such good teams as Southern California, Washington and California. But it was no match for the powerful Crimson Tide, as Alabama won 24–0 to claim its third national title under Wallace Wade.

9
JOHNNY MACK AND POOLEY

Johnny Mack Brown was a star player for Alabama on the 1925 national title team. Brown could not only play, but he also had the looks of a movie star. At Dothan High School in Alabama, he was chosen as the most handsome senior. At Alabama, fans nicknamed him the "Dothan Antelope" because of his running ability.

Brown was certainly good enough to play professional football, but in 1926, the pro game was not the high-paying game it is now. After auditioning for the movies, MGM signed him to a contract. He ended up starring in over 160 films, mostly as a cowboy. In 1930, Brown played the title role in *Billy the Kid*, which held its world premier at the Bama Theater in Tuscaloosa. He appeared in movies with John Wayne, Greta Garbo and Joan Crawford. Now in the College Football Hall of Fame for his exploits at Alabama, Brown also received a star on the Hollywood Boulevard Walk of Fame. He passed away in 1974.

Allison Thomas Stanislaus Hubert, better known as Pooley, was a teammate of Johnny Mack Brown's. Hubert graduated from high school in Meridian, Mississippi. Pooley Hubert then became one of the best players to ever don an Alabama uniform, called by his coach, Wallace Wade, "the best leader of men I've ever coached." After college, Hubert played professional football with the New York Yankees (yes, a football team at the time), where he played with the immortal Red Grange. In 1931, Hubert was selected as head coach at Southern Mississippi, where he went 26-24 from 1931 to 1936. He moved to the Virginia Military Institute in 1937 and was 43-45

until 1946. He eventually moved to Waynesboro, Georgia, and coached at Edmund Burke Academy. Hank Crisp, a longtime Alabama coach and administrator, said that "Pooley was the greatest player I ever helped coach in over forty years," and to football fans of Alabama, Pooley Hubert will forever represent what it means to wear the Crimson colors.

10

FOOTBALL FREDDY

Fred Sington made the All-American team for the 1930 season at his tackle position. Sington attended Phillips High School in Birmingham, where he starred in football, baseball, basketball and track.

Ernest Tucker was his high school coach at Phillips. Sington played at Alabama at six feet, two inches tall and weighing 230 pounds—a big boy in 1930. Not only excelling in football and baseball at Alabama, Sington also won virtually every academic honor at the university, including serving as senior president of the student body and being a member of Phi Beta Kappa.

During the win over Tennessee in 1930, Sington showed his courage and football smarts. He recalled:

> Bobby Dodd, the future Georgia Tech coach, was giving us some trouble. So we got in the huddle with Coach Wade. You didn't speak up much to Coach Wade, he ran it. But I did that day. "Coach," I said, if you change me from right tackle to left"—Dodd was retreating to his right and when I was right tackle he got further and further away—"I believe I can slow him down some." Coach Wade told me to go ahead.

The next day, the *Tuscaloosa News* reported that "Sington broke through the Tennessee offensive front repeatedly." Sington also recalled how the players feared Wade:

You never went to see Coach Wade. It was like they tell you in the navy: don't volunteer. Finally, you'd get up the courage to see the man, and here you'd be, six-two or six-three and 230, walking into his office with a trembling heart. You'd get up courage to speak and you'd say, "Coach Wade, I'd like to do so and so." He'd always say, "How's that?!" Most of the time, you wouldn't even repeat it.

Recalling another example of Wade's toughness after going with him to Duke, Sington said:

I'll never forget the first practice after we went to Duke. A boy from Philadelphia held his hand up. We expected him to ask about some play he didn't understand. He said, "Coach, I just wondered. They're having a dance Friday night before the game. Will it be all right if we go?" I nearly fell out of my chair. If we had been in a room full of gasoline and someone had struck a match, I couldn't have been more apprehensive. But Coach Wade realized he was in a new world. All he said was, "No."

Sington became so well known during the 1930 season that the song "Football Freddy," released that year by Rudy Vallee, celebrated his football success. In part, it went like this:

The women folks galore,
They know how he can score,
Especially when the lights are low
Football Freddy, rugged and tan.
Football Freddy, my collegiate man.
When he huddles, he's dynamite.
How he cuddles on a Saturday night!
He's got style, he's got class,
Oh, how they fall for his forward pass!
X, Y, Z! B, V, D! He doesn't miss a sign,
Ha, cha, cha! Sis, boom, bah!
Oh, how he runs for a sweet ma-ma!

Grantland Rice, the famed sportswriter, heaped praise on Sington: "Tackles such as Sington rarely come along." Knute Rockne called him the greatest lineman in the country. Wade always said that Sington was one of the best players he ever coached. In fact, they thought so much of each other that Sington joined Wade at Duke as an assistant coach from 1931 to 1933.

Sington also played professional baseball during the summers while at Duke. His career in baseball spanned ten years, and he played for the Washington Senators and Brooklyn Dodgers. While with Chattanooga in the minor leagues, he led the Southern Association in batting, with a .384 average, earning league MVP honors.

After his playing days, as well as his time serving in World War II, were over, Sington opened up a chain of sporting goods stores in Alabama. He also officiated Southeastern Conference football games and served as president of the University of Alabama Alumni Association twice. In this role, he played a large part in bringing Bear Bryant to Alabama in 1957. He recalled what happened:

> *Alabama was playing Tulane in Mobile in 1957 and Dr. Rose* [president of Alabama Frank Rose] *sent word he wanted to see me. He said he wanted me to go to Houston with him after the game. Jeff Coleman took my wife, Nancy, home so Dr. Rose, Ernest Williams, a trustee and I could fly to Houston that night.*
>
> *We got a suite on the top floor of the Shamrock, and Bryant came up and we talked. Coach Bryant was concerned about two things. He asked about Hank Crisp, who was serving as athletic director at Alabama at the time. Coach Hank had recruited Bryant out of Arkansas. Bryant wanted to be sure Coach Hank would be taken care of if there was a coaching change. I admired him for that.*
>
> *The other thing he was concerned about was his control over the football program. He asked Dr. Rose about it, and Dr. Rose told him, "You'll run the show." As I remember, Texas A&M was having a good season, and Bryant wanted to keep it quiet, but there was an agreement that night. He agreed to come back.*

Helping to bring Bear Bryant back to Alabama would, by itself, ensure that Fred Sington would be remembered forever by Crimson Tide football fans, but he accomplished so much more. He loved the state of Alabama, and he loved the University of Alabama. He contributed years of service to both. He was chosen as Birmingham's Man of the Year in 1970 and worked tirelessly to bring the Hall of Fame Bowl to Birmingham. In 1991, the press box at Legion Field was named in his honor. Sington was inducted into the College Football Hall of Fame in 1955, the same year his old coach, Wallace Wade, was inducted. The State of Alabama still presents the Fred Sington Trophy to the state's top male and female athletes.

II

JOHNNY CAIN AND THE
BARON OF BARLOW BEND

Two leaders of the 1930 national champions of Alabama were Johnny Cain and Frank Howard.

Cain had played at Sidney Lanier High School in Montgomery under Herschel Caldwell, who had played for Wallace Wade at Alabama. In his three years on the varsity at Bama, the Tide was 27-2. Zipp Newman, famed sportswriter, wrote about Cain:

> *From all the great backs I have seen play since 1913, I rate Johnny Cain the best all around back I ever saw. He is one of the South's all-time long and accurate punters—a coffin-corner specialist. He was a fine deceptive left-handed passer. He ran with a hip-swinging motion—terrific in a broken field. He was a fine power runner, and I never saw a more deadly tackler.*

Cain is listed as the punter on Alabama's All-Century Team, selected in 1992.

From 1947 to 1972, Cain was an assistant coach at Ole Miss, where he coached, among others, Archis Manning. While at Ole Miss, the Rebels won a national championship and six SEC titles.

Frank Howard was born in Barlow Bend, Alabama, on a farm, hence the nickname "Baron of Barlow Bend." He graduated from Murphy High School in Mobile, which he said was "three wagon greasings from Barlow Bend." After playing on that great 1930 Alabama team with Fred Sington and Johnny Cain, Howard went into coaching. He was nominated at a Clemson Athletic Council meeting in 1940 to become head football coach. Howard, standing in the back of the room, spoke up, "I second that nomination." He got the job and won 165 games at Clemson from 1940 to 1969.

12

"Coach Wade's Teams Got the Ball Rolling Around Here"

The hiring of Wallace Wade established Alabama as a storied name in national football circles. None other than Bear Bryant said, "Coach Wade's teams got the ball rolling around here. There is no question about that. There is no doubt that his teams back then are more responsible than anybody else for the tradition we have. I hold all of those Alabama teams back then in reverence."

Wade, ever a modest man, later on said, "I would not go so far as saying we started tradition at Alabama, but I admit we had a solid hand in it." But Al Browning agreed with Bryant, writing, "Wade led Alabama to its thundering entrance to national acclaim, spawning Crimson Tide tradition as we know it." Keith Dunnavant, an Alabama football historian and writer, adds that Wade transformed the Crimson Tide into a national power. Wayne Hester, at one time sports editor of the *Birmingham News*, wrote, "A 'Bear' led Alabama football through its first great era and established the rich tradition of the Crimson Tide. No, not that Bear. This Bear was Wallace Wade. Some people call him the Godfather of Alabama football, but his players called him the Bear." Yes, there was a Bear on the Alabama campus before Bear Bryant. The first four conference championships and first three national titles in Alabama football history were earned under Wallace Wade.

Bear Bryant arrived on campus at Alabama in the fall of 1931. Bryant had fallen in love with Wallace Wade's program, even leaving a game in 1931 to listen to the radio as Alabama beat Washington State in the Rose Bowl. As he said, "I was in Dallas at an all-star game an Arkansas coach was

Wallace Wade, the coach who won the first three national titles in Alabama football history, is shown after he retired from coaching at Duke. Coach Wade enjoyed raising cattle on his farm outside Durham, North Carolina. *Courtesy of Perkins Library, Duke University.*

in, but I caught a streetcar back to the hotel so I could listen to the Rose Bowl on the radio. The Arkansas people never knew that."

At this time, Alabama football had quite a few players from Arkansas. Many had been sent to Tuscaloosa by Jimmy Harlen, a Pine Bluff businessman who developed a strong affection for Alabama. But it is doubtful if Bryant would have decided to attend Alabama had it not been for the winning tradition established by Wallace Wade. Listening to the 1926 Rose Bowl involving Alabama's dramatic win over Washington captivated the twelve-year-old Bryant, from Moro Bottom, Arkansas.

Wade's departure for Duke disappointed Bryant, but he arrived through the recruiting of Hank Crisp. Bryant, for the rest of his life, admired Coach Crisp. He said:

> *I practiced with the team as a redshirt freshman. Johnny Cain and I roomed together. We stayed in the gym. All the hell-raisers stayed in the dorm, but I always stayed in the gym. We all had jobs, and Cain had a hard one. He had to get me to class every day at Tuscaloosa High. Basically, I was a*

lazy fat-butt who could barely read and write. [Bryant had enrolled at Tuscaloosa High School in math and other classes to complete requirements for admission to Alabama.] *I was in awe of those great players. I was scared, and embarrassed and broke. Ears Whitworth helped me a lot, but the guy who really saved me was John Tucker. He was older and more experienced than me. When he talked, I listened.*

Bryant and Wade became close after Bryant entered the coaching ranks. They called each other quite regularly while Wade was retired and living in Durham, North Carolina, and Bryant was coaching at Alabama from 1958 to 1982. "I expect I knew Coach Wade better than his players ever did because they were all so scared of him," Bryant said. "The first time I really got to talk to him much was when I was at North Carolina Pre-Flight [in the navy], and he was at Duke." (Bryant coached the Pre-Flight team in 1944 to a 13–6 win over Duke. The head coach of Duke at the time was Eddie Cameron, although Bryant evidently had a chance to talk to Wade. Bryant obviously turned around the program at the North Carolina Pre-Flight because the previous year, 1943, Duke had clobbered Pre-Flight 42–0, again under Cameron.) Bryant added:

Then, later, when I was coaching at Kentucky in 1949, Coach Wade and I were on a train ride together to San Francisco. We were going to a convention, and there were two trains. We got snowbound a few miles from Grand Island, Nebraska, and were stuck for three days. One train was about two miles ahead of us, and it was without food and drink. But our train was loaded. We had the best eating and carrying-on you can imagine.

Wade made special visits back to Alabama after he retired from coaching. He came to see games, be inducted into the Alabama Sports Hall of Fame and visit Bryant. During one practice, a highway patrolman had been sent by Bryant to pick up Wade and bring him to the field. The car brought Wade close to where Bryant was conducting practice, and Bryant immediately signaled for his players to gather around the elderly man. "Boys, this man here is the reason you and I are at the University of Alabama."

On another occasion, September 9, 1982, at Legion Field, Duke was playing Alabama. Wade had long been retired but was invited to the game. Bryant was on the field about fifteen minutes before the kickoff, when he was told Wade was in the press box. Frank Dascenzo, longtime sportswriter for the *Durham Herald-Sun*, described what happened:

Bryant, guarded by two Alabama state troopers, came around the Legion Field fences to the press box elevator. When the doors opened behind press row, Bryant stood and greeted Wade. Understand now, this is highly unusual for a head coach to be in the press box moments before his team is to begin a game. In normal situations, Bryant would have been in the Alabama locker room delivering last minute instructions. Bryant wore his black and white checkered houndstooth hat, a sky blue short sleeve shirt and red necktie. Wade had his white cowboy hat on, no tie, but wore a white long sleeve shirt, buttoned at the neck. It was 92 degrees at kickoff. And no wind. The two Southern gentlemen shook hands and began conversing. By this time, the famed Alabama Million Dollar Band had taken the field, and the two teams, through with warm-ups, headed back to their dressing rooms.

When the two men shook hands, a tremor shook the press box. One night in Birmingham the Bear was commanded by the presence of one Wallace Wade. Grown men stood up to get a look and if one person said "excuse me" so did 12 others, all trying to elbow their way to get a glimpse of Wade and Bryant together. The scene had power. It had history. It had winners and it had a heavy overtone, not just for the two schools but for college football. One night in Birmingham, two men commanded an audience that, if stares were of monetary value, everyone would have gone home a millionaire.

Bryant stayed, and stayed. The captains came on the field for the coin toss and less than three minutes remained on the scoreboard clock. Bryant and Wade were eyeball to eyeball, laughing. Wade chuckled, then Bryant. Wade pointed, then Bryant pointed.

Miraculously, the Bear made it down to the sidelines in time to see the kickoff. Duke played an excellent first half and trailed only 14–12. It is assumed Bryant had a few choice words at half-time because the final score was 35–12.

I've often wondered if they'd have held up the start of the game that night if Bryant had remained upstairs talking with Wade. I guess they would have.

In 1980, Wade came back to Tuscaloosa for a fiftieth reunion of the 1930 team. He was a man then eighty-eight years of age but still as sharp as could be. Bear Bryant was close to retirement himself. The first Alabama Bear, Wallace Wade, and Bear Bryant, the most successful coach in the country, found time to talk alone—the two men most responsible for Alabama being

at the top of the college football world. It's not known exactly what the two talked about; probably it included the 1930 team, Bryant's 1980 team and prospects for the future, how Wade was enjoying retirement, that train trip they took together and ended up stranded in the middle of Nebraska, Hank Crisp, Johnny Mack Brown, how much longer Bryant would coach and changes in the game over the years, both good and bad. One thing is for sure, coaching greatness sat side by side as Coach Wade and Coach Bryant talked that day in Alabama.

Wallace Wade's impact on the Alabama football program will forever be felt. He simply established the tradition of outstanding football in Tuscaloosa. His record speaks for itself. He won over 80 percent of his games, won the first four conference championships in the history of Alabama football and won its first three national titles. He won what many football historians call the most important game in the history of southern football: the 1926 Rose Bowl. All-Americans played for him, such as Pooley Hubert, Fred Sington and Johnny Cain. A movie star played for him—Johnny Mack Brown. These players and others generated enormous publicity for the University of Alabama, and there is no doubt that the growing enrollment of students during the 1920s was due in large part to the national acclaim of Wade's teams. Denny Stadium, what is now Bryant-Denny Stadium, was started with funds from the 1926 and 1927 Rose Bowls. Alabama's mascot, the elephant, was started with the 1930 game.

Wade was an innovative coach. He was one of the first football coaches to have his own radio show on WAPI in Birmingham. The 1927 Rose Bowl was the first national broadcast of a football game on radio. Year-round conditioning was not practiced in the South before Wade started it at Vanderbilt and continued it at Alabama. His coaching schools were among the first to appear, and his network of high school coaches who had played for him was among the most extensive recruiting tools of any school in the country. His use of low-cut shoes, especially on the Dothan Antelope, Johnny Mack Brown, to increase speed, was a strange look in an era of high-top shoes. Wade even got a shoe salesman to experiment with different types of athletic shoes, in one instance placing football cleats on baseball shoes. Lighter padding that still offered ample protection was introduced by Wade. In practices, Wade used a metronome, being such a stickler for precise timing. He was sought after for his defensive genius and his kicking game knowledge.

Wade picked his successor, Frank Thomas, who went on to coaching greatness at Alabama. Probably most notable of all is that the fame of his

Martha Witt Burleson was a well-known cheerleader for Alabama in the 1930s. She was so popular that in the 1938 Rose Bowl against California, the California fans started chanting, "We want Martha!" until Martha ran over to acknowledge the cheers. Martha was on the cover of the magazine shown here. *Courtesy of T. J. Weist.*

great teams reached over state lines to capture the imagination of a young country boy growing up in Arkansas. As Allen Barra wrote in *The Last Coach*, "Bryant, who would become as awe-inspiring as any coach to ever step onto a college field, never got over his awe of Wallace Wade." Bear Bryant never got to play for Alabama's first bear, Wallace Wade, but Wade was certainly a huge factor in Bryant coming to Tuscaloosa.

A former player of Wade's at Alabama, J.B. Whitworth, became head coach at Alabama. Several of his assistant coaches had lasting impacts on the program, such as Hank Crisp, Paul Burnum and Carney Laslie.

Sure, Wade left Alabama. Maybe he did feel a little unappreciated after having less than stellar years between 1927 to 1929. He still produced good teams in 1927, 1928 and 1929, but directly because of Wade, Alabama fans wanted championships every year. Wade's early success worked against him in this respect. So he decided to leave; more money beckoned, and the chance to have total control over his program and the opportunity to start anew factored into his decision. But he honored his contract, gave Alabama a parting gift of yet another national title and never uttered a negative word about the university he had grown to love. In fact, in many interviews in years to come after leaving Tuscaloosa, he had only praise for Alabama. In Frank Thomas, he chose for Alabama the best coach in the country available to continue what he had started.

Bear Bryant will always be the coach against whom others are measured at Alabama, and rightfully so. His coaching greatness was captured when Bum Phillips said of Bryant, "He can take his'n and beat your'n and then take your'n and beat his'n." Coach Bryant is an icon; his success and personality captured the imagination of Crimson Tide football fans everywhere. Grown men don houndstooth hats just to show their support for the great coach, and young boys dream of playing for him, even today, thirty years after his death.

William Wallace Wade, the first bear to stalk the Alabama sidelines, will forever be remembered as the "godfather of Alabama football." He started the greatness that shook the college football world. He will never, and should never, be forgotten.

13

FRANK THOMAS

"He Played Football Under Rockne at Notre Dame"

It's amazing the amount of football sense that Thomas kid has. He can't help becoming a great coach some day.
—*Knute Rockne*

There is a young backfield coach at Georgia who should become one of the greatest coaches in the country. He played football under Rockne at Notre Dame. Rock called him one of the smartest players he ever coached.
—*Wallace Wade*

Knute Rockne, the immortal former football coach of Notre Dame, spoke the first lines above about Frank Thomas, who played for Rockne at Notre Dame from 1920 to 1922. Wallace Wade recommended Thomas to succeed him as Alabama's football coach in the second quotation. Well, Rockne and Wade were right; Thomas became the head coach of the Alabama Crimson Tide in 1931 and won 115 games, while losing only 24, with 7 ties, in a career spanning to 1946. Thomas won two national championships and four Southeastern Conference titles while at Alabama.

Frank Thomas was born in Muncie, Indiana, in 1898. Thomas was an outstanding high school football player in Chicago, where his family had moved. After being recruited to play quarterback at Notre Dame, Thomas had as a roommate George Gipp. Gipp was one of Notre Dame's greatest All-American players but developed a throat infection in 1920 and tragically died a few weeks later. While playing for Knute Rockne at Notre Dame from

1920 to 1922, Frank Thomas and his teammates won twenty-seven games against two losses and one tie.

Winning football games was something Thomas did throughout his career. As head coach at Tennessee-Chattanooga in the 1920s, before taking over at Alabama, Thomas won thirty-four games, lost eleven and tied two in four seasons.

In 1931, Wallace Wade, who had established Alabama as a football power by winning the Crimson Tide's first three national championships, resigned as head coach. Wade tapped Thomas, who was then an assistant coach at Georgia, to be his successor. The year 1931 was tough for many Americans. A line from a popular song—"Brother, can you spare a dime?"—summed up the feelings of many as the Depression gripped the nation. Bread lines were a sobering sight, as the number of unemployed and hungry grew each day. Bad news even came to the sports world early in 1931, as the most famous football coach in the country, Knute Rockne, died in a plane crash.

For fans of the University of Alabama football team, there was a sense of great pride as the Crimson Tide finished undefeated and won the 1930 national championship. Uncertainty and sadness also was felt, as the architect of that great team, Wallace Wade, resigned as head coach to accept a similar position at Duke University.

Following the legend of Wallace Wade as head man of Alabama football would not be an easy task. Most of the starters from the 1930 national championship team were not returning, and this, combined with the relatively unknown Thomas assuming command, made Crimson Tide fans apprehensive about the future.

Twenty thousand fans turned out on September 26, 1931, to see what this new coach was like. They enjoyed what they saw, as Alabama rolled over Howard University 42–0, with halfback Leon Long scoring three touchdowns. Alabama would go on to finish with nine wins and only one loss in 1931, the loss coming to powerful Tennessee in Knoxville. The second great era of Alabama football, under Frank Thomas, had begun.

Another person who would have quite an impact on Alabama football arrived on campus in Tuscaloosa in 1931. Bear Bryant came to the Capstone the same year as Thomas, although Bryant did not earn his first letter in football until 1933. Great admiration developed between Bryant and Thomas. In his autobiography, Bryant had this to say about playing for Coach Thomas:

We thought then, and I know now, that Coach Thomas was ahead of the game. There wasn't a whole lot he didn't know about it, and there sure isn't much we do now that he didn't know then. If it bothered him succeeding Wallace Wade, he didn't show it. His first four Alabama teams lost a total of four games, and our 1934 bunch went undefeated all the way to the Rose Bowl.

Win they did, finishing 9-1 in 1931 and scoring 370 points to only 57 for the opposition. In 1932, Alabama was 8-2, and in 1933, Alabama won seven, lost one and tied one. In 1934, the record was undefeated at 10-0, capped by a win over Stanford in the Rose Bowl for the national championship. After his first four years as head man in Tuscaloosa, Thomas had won thirty-four games with only four losses and one tie.

Bear Bryant, a player on the 1934 national championship team, would eventually become the greatest coach in Alabama football history, perhaps the best to ever walk on a college football field. Bryant played as an end on offense and was a vicious tackler on defense. Bryant's future toughness as a coach was exhibited as a player in a game against Tennessee in 1935. He had broken his leg in the previous game and was ruled unavailable for the Tennessee game. But before the game against the Volunteers, Thomas said, "Bryant, can you play?" Play he did, as Bryant led Alabama to a 25–0 win.

Thomas hired Bryant as an assistant coach for the 1936 season, realizing the potential coaching greatness of his former player. Bryant would always look up to and admire the coaching genius of Thomas and used much of what he had learned under Thomas after he became a head coach.

In fact, Thomas, more than any other person, deserves credit for recognizing the coaching potential of Bryant and leading him to the coaching profession. When Thomas went to speak and teach football at coaching clinics, he often took Bryant with him, and he noticed how players and coaches would react so positively to Bryant. Bryant, who turned to Thomas for advice throughout Thomas's life, said,

Where Coach Thomas was great was during a game. He could see things, adjust to things. You talk about geniuses. There wasn't much Coach Thomas didn't know about anything. The thing about Coach Thomas, like every fine coach, was that he was sound. He beat you with the things he did best. Occasionally, he would have one little new play for the opponent, but basically he preached blocking and tackling and executing. I used to call long distance to get Coach Thomas's advice years after he quit coaching, and I visited him every chance I got.

Frank Thomas led Alabama to another national title in 1941, capping the season with a victory over Texas A&M in the Cotton Bowl.

Alabama did not field a team in 1943 due to World War II. In 1944, Thomas had a team composed mostly of freshmen and military rejects. Led by quarterback Harry Gilmer, this team, called the "War Babies" by Thomas, won five, lost two and tied two, including a 29–26 loss to Duke in the Sugar Bowl. "I've never been prouder of any team I've coached," Thomas said of this team.

Alabama was even better in 1945, finishing with a 10-0 record. The Crimson Tide demolished Southern Cal 34–14 in the Rose Bowl to cap a perfect season.

After the 1946 season, due to health complications from a heart condition and high blood pressure, Thomas resigned as head coach of Alabama. He was only forty-eight years old, but his health was such that he had to conduct most of the team's practices in 1946 while riding in a trailer because he could not stand for long periods of time.

In 1951, Thomas was inducted into the College Football Hall of Fame. He passed away in 1954 in Druid City Hospital in Tuscaloosa.

His legacy should live forever in the minds of all Alabama football fans. Grantland Rice, the most famous sportswriter of the era, sensed what it would be like without Coach Thomas, called by many Tommy:

> *The winds from Tuscaloosa*
> *Now face a mournful ride,*
> *For Tommy isn't back to*
> *Lead the Crimson Tide.*
> *The winds from Tuscaloosa*
> *Have carried old refrains*
> *Of victory through Southern*
> *Suns and driving autumn rains.*
> *From bowl to bowl the*
> *Crimson Tide has fought its way to fame,*
> *But Tommy's on the sidelines now,*
> *And nothing seems the same.*

14

DIXIE AND THE ALABAMA ANTELOPE

M any players would get votes for the top player in the history of Alabama football, but Don Hutson would be near the top of any such selection. In fact, many would place him as the very best. There is no question that the success of Dixie Howell's passing to Don Hutson changed the way college football teams looked at the forward pass. This combination forced teams to realize that passing needed to be incorporated in their game plans in order to be as successful as possible.

Out of Pine Bluff, Arkansas, it seemed that Hutson was more suited for baseball and being a sprinter on the track team than being a football star. It wasn't until 1934 that Hutson really broke out and showed the nation what he could do.

After scoring four touchdowns against Georgia Tech in 1934, three catching a pass and one running, Tech coach Bill Alexander praised Hutson, saying, "All Hutson can do is beat you."

Bear Bryant, who played end opposite Hutson in 1934, said:

> Don had the most fluid motion you had ever seen when he was running. It looked like he was going just as fast as possible when all of a sudden he would put on an extra burst of speed and be gone. He used to wear his track suit under his baseball uniform so he could run the dashes between innings. At Alabama he got up to about 195 pounds. He could eat like a horse and not gain weight. He was, in every respect, a complete football player. But oh, my, could he catch passes. In all my life, I have never seen a better pass receiver.

Bryant and Hutson were roommates and the best of friends. They had also played on opposing teams in high school, both being from areas in Arkansas close to each other.

The feelings about Hutson are best summed up by Frank Thomas's statement in 1934, when he said, "Hutson is the best player I ever coached."

Hutson graduated from the University of Alabama in 1935, and he signed with the Green Bay Packers. Hutson would play eleven years for the Packers, until his retirement in 1945, by which time he held eighteen NFL records. He caught ninety-nine career touchdown passes, a record that stood until 1989, when Steve Largent caught his 100th. In his pro career of eleven seasons, Hutson led the league in receptions eight times, in receiving yards seven times and in touchdown receptions nine times. He was named the NFL's most outstanding player twice, and his teams won three league championships.

Left: Dixie Howell helped lead the Crimson Tide to the 1934 national title. He was part of the famous Howell-to-Hutson (Don) passing combination. After his playing days, he was head football coach at Arizona State and Idaho. *Courtesy of Paul Bryant Museum.*

Just as he had, along with Dixie Howell, revolutionized the college passing game, Hutson is generally regarded as the man who brought the forward pass to the NFL. When he began his pro career in 1935, few teams threw very much, but his catching ability and prowess in running after the catch convinced other NFL teams to

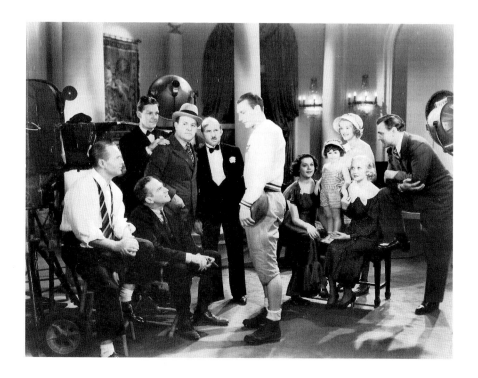

In this picture, Dixie Howell, an All-American, is being filmed for the leading role in the movie *The Adventures of Frank Merriwell*. Howell was in California in February 1935 for the filming. *Courtesy of T.J. Weist.*

incorporate passing into their plans. In 1951, he became the first Packer to have his number retired. Hutson passed away at the age of eighty-four in 1997.

Dixie Howell, who was from Hartford, Alabama, was the man who threw most of the passes that Hutson caught. But Howell was known for more than his arm, as he could run with the ball and was an outstanding kicker, a true triple threat.

Frank Thomas said:

> *Dixie's mental reactions were the thing, to my mind, that made him great. He had the ability to see and realize the situation a split second ahead of the usual player. George Gipp, one of Notre Dame's greatest whom I had the pleasure of playing with, had the same quality. To me Howell had something that few athletes possess—a touch of genius in his makeup.*

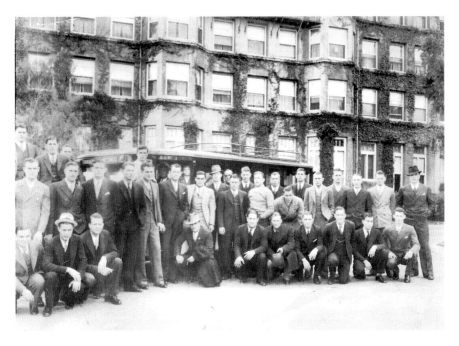

The 1934 team in California for the January 1, 1935 Rose Bowl. This team won the fourth national title in Alabama history. Bear Bryant, who played end on the team, is in the first row of players, standing fifth from the left. Just to the right of him is head coach Frank Thomas, kneeling with a hat on his head. Alabama beat Stanford in the Rose Bowl. *Courtesy of T.J. Weist.*

After leaving Alabama, Howell signed a professional baseball contract with the Detroit Tigers. Unfortunately, he suffered a head injury when a foul ball hit him in the head while practicing. This injury cut short a promising career in baseball. He also spent one season playing for the Washington Redskins pro football team. From 1938 to 1941, Howell was head football coach at Arizona State and compiled a 23-15-4 record. After serving in World War II, Howell was head coach at Idaho from 1947 to 1950, where he went 13-20-1.

After his coaching days, Howell went into private business. He was inducted into the College Football Hall of Fame in 1970. His old teammate, Bear Bryant, decided to start awarding the MVP of each spring A-Day game with the Dixie Howell Award. Howell passed away in 1971 at the age of fifty-eight from cancer.

15

ASSISTANT COACH BEAR BRYANT

Holt Rast, who became an All-American at Alabama, remembers Bear Bryant as an Alabama assistant coach:

Coach Bryant was such a charismatic fellow. He was a handsome guy, the gals loved him and he had such an air about him that we all respected, and we all loved him. If he got after you, he could really get your attention in a hurry. One of my early recollections was back into when I was going with my wife, who I later married. At that time, the coaches did not like for the boys to date the girls, to be seen being too friendly with the girls. I remember meeting Ann one day; she came in on the train, and for some reason Coach Bryant was riding by in his old car, and he didn't say anything to me, but that afternoon we were in the field and had backs on end, and I got knocked down pretty good. I remember this till today, he yelled, "That's the way to do it, take him back over to the girls' dormitory." Our field was right next to the new hall, and he says, "Take him to the girls; he likes to be with the girls anyway," so he got my attention.

Rast lettered at Alabama from 1939 to 1941. He was inducted into the Alabama Sports Hall of Fame in 1977 and was a first team All-American in 1941. He served two terms in the Alabama House of Representatives and earned two Purple Hearts and a Silver Star as an army major in World War II.

In the 1939 game against Tennessee, Rast remembers that assistant coach Bryant got pretty upset with his play:

I remember well the game of 1939, when Johnny Butler ran all over us and ran back and forth across the field. Fred Davis and I were playing next to each other. Fred was playing defensive tackle, and I was playing end. Johnny Butler came by once, and I missed him. He came back again. We both missed him. I looked over at Fred and I said, "Fred, I missed him again," and Fred said, "Don't worry, he'll be back."

Rast also recalled when Bryant was an assistant at Alabama and his work with kids:

When I was a freshman at the university, Coach Bryant was a counselor at Camp Winnipeg up in Canada. Coach Homer Thomas was head of the athletic department for the Birmingham City Schools, and he had a camp in Canada where he took people like Coach Bryant. Coach Bryant had these kids, and I guess all of his life he has had the charisma to work with people and to motivate people and to bring out the best. I remember Jerry Sherrill telling me that if Coach Bryant told those kids to walk over a cliff in single file, they would all do it. He just had that sort of charisma.

Bear Bryant coached his last season as an assistant at Alabama in 1939. He accepted a job as an assistant to Coach Henry Sanders at Vanderbilt. The University of Alabama *Alumni News* reported the sad event:

There were tributes paid to Bear Bryant during a season-ending banquet. Bryant is yielded with regret to Vanderbilt as he has been a great football player and a great assistant coach for Alabama. President Foster expressed his best wishes to "Bear" in his new job and said he had made a great addition to the athletic traditions at the university. Coach Thomas said he hated to lose the services of one of the most promising coaches in the Southeastern Conference.

So, after the 1939 season, Bear Bryant would be leaving the school where he had played for four years and been an assistant coach for four years. Between other coaching stops and a world war, it would be the 1958 season before the man who would take Alabama to unprecedented success came back to Tuscaloosa.

Bear Bryant didn't get his toughness from Frank Thomas. Thomas was much milder in temperament than Bryant. Growing up in Moro Bottom and Fordyce, Arkansas, is a big part of what made him the coach he became. One story from Chet Darling, who attended a Fordyce High School

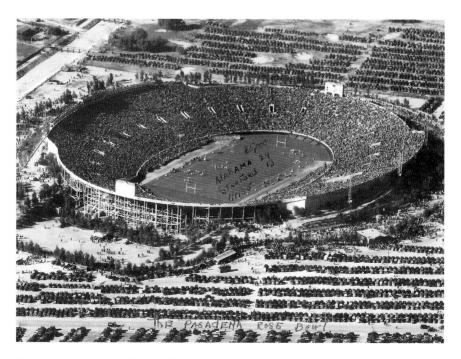

An aerial view of the 1935 Rose Bowl, won by Alabama over Stanford, in front of eighty-five thousand fans. Dixie Howell scored on a 67-yard run and threw a 59-yard touchdown pass to Don Hutson. He gained 111 yards rushing and passed for 160 yards, while averaging 44 yards a punt. *Courtesy of T.J. Weist.*

basketball game in which Bryant was playing, demonstrated Bryant's tough streak. There was an opposing player giving Bryant a tough time. Darling recalled the game: "Bryant hit that boy in the mouth, and his teeth came out like throwing a handful of corn on the floor. They stopped the game. Bryant would get in the first lick; he'd hit you, and that'd be the end of it." Of course, Bryant probably thought fighting a person was rather boring after wresting with a bear.

Although he left Alabama in 1939, Bryant never lost touch with Coach Thomas. He would call Thomas when he was at Vanderbilt, Maryland, Kentucky and Texas A&M. Bryant greatly admired Coach Thomas for his football knowledge and ability to lead men to championships.

Bryant, when asked one time about Thomas's influence, replied:

> *Well, how much can a man influence you? I used to call long distance to get Coach Thomas's advice even years after he quit coaching. Even after he*

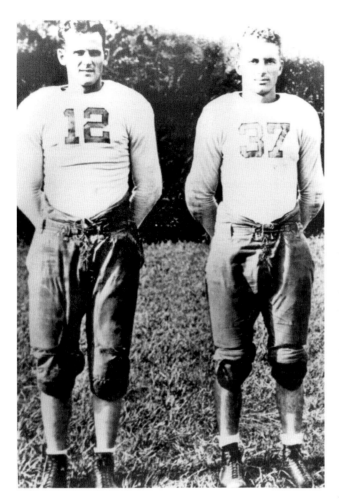

Bear Bryant (left) and Don Hutson (right) were the two ends on the 1934 national champion team. Bryant would go on to become Alabama's best coach ever, while many would claim Hutson was Alabama's best player ever. Hutson played for eleven years with the Green Bay Packers, was All-Pro nine times, led the league in receptions eight times and was twice named NFL MVP. When he retired, he held eighteen NFL records. *Courtesy of Paul Bryant Museum.*

got sick, I chartered a plane just to spend a few hours with him. When I was at Kentucky, I visited him every chance I got. Just being around him could help you.

But for the upcoming 1940 season, Bear Bryant would continue to get coaching training at Vanderbilt. But the man Frank Thomas had coached and mentored would be back, and when he came back, he would take Alabama football to success even beyond what Wallace Wade and Frank Thomas had achieved.

16

A Year Without Football in Tuscaloosa

World War II raged on in 1943. In 1942, Adolf Hitler had ordered that the Russian city of Stalingrad be taken. The Russians proved more than an able adversary, however. The Soviet military command ordered its soldiers, "Before you die, kill a German, with your teeth if necessary." Hitler suffered a devastating defeat in Stalingrad. On January 31, 1943, after over 100,000 of his men were killed in the course of three weeks, the German commander gave up. Combined with those killed in the Battle of Stalingrad and deaths by starvation and exposure to disease in Soviet prison camps, only about 6,000 of the 300,000 Axis soldiers in the original attack force on Stalingrad survived World War II. Few events of this epic war demonstrated the price humans paid for freedom to such an extent.

Japan held sway over close to 25 percent of the earth's surface before America and its allies rallied and began to push the tenacious Japanese back toward their home islands, the Land of the Rising Sun. Japan aspired to nothing less than domination of eastern Asia and the Western Pacific. But the Battle of Midway, the most decisive sea confrontation of the war, showed the Japanese that they had bombed the wrong place in the wrong country. That place was Pearl Harbor, and that country was the United States. Japan's losses at Midway were staggering. At least three hundred Japanese planes were shot down, and three of its carriers were sunk.

Meanwhile, back in the state of Alabama, citizens were proud of the war effort and contributions of its towns and people. Birmingham was producing tons of steel for use in the war. General John C. Persons, from Birmingham,

commanded the Thirty-first Infantry Division. Lieutenant Colonel David Daniel, of Alabama, formerly a Birmingham-Southern college student, led paratroopers during the D-Day invasion of France. General Holland M. Smith, born in Hatchechubbee, Alabama, and who attended Auburn University and the law school at the University of Alabama, helped plan the invasion of Okinawa and commanded U.S. forces in the invasion of Iwo Jima. General Smith trained one of the best amphibious assault forces in the world, once boasting, "I could have landed them in the mouth of hell if the joint chiefs of staff had picked the target." In all, some 250,000 Alabamians served in the military during World War II, and approximately 6,000 lost their lives.

A truck carrying a Japanese submarine parked on Dexter Avenue in Montgomery, and long lines of curious people, estimated at twenty-five thousand, bought one-dollar savings stamps to view the submarine. Alabama became a major location for prisoner-of-war camps. German POWs numbered about fifteen thousand. As with most of the nation, gas and meat rationing affected nutrition and transportation for the people of Alabama.

Of course, by 1943, many former and present Crimson Tide football players were involved in a more serious endeavor: war. Bear Bryant was a lieutenant stationed in Africa. Johnny Roberts, a fullback on the 1937 team, was missing in action in the Pacific. Johnny was a naval flyer on the aircraft carrier *Enterprise*. Thomas "Hog" Borders, a tackle for the Tide in 1940, was missing in action in Africa. Both Roberts and Borders were from Birmingham. Another former Tide football player had been killed in a plane crash while in training in the United States. Cliff "Swede" Hanson, a standout tackle on the 1940 team, was killed in a bomber crash in Tennessee. Joe Kilgrow, an All–Southeastern Conference halfback on the 1937 team, was awarded for "outstanding leadership displayed under fire in New Guinea." A native of Montgomery, Kilgrow was a backfield coach at Mercer University when he was called to active duty.

Bryant, the former player and assistant coach for Frank Thomas, sailed on the ship *Uruguay* to Africa. The *Uruguay* was rammed by another American ship. Bryant ran topside, where he found hundreds of other frightened soldiers. There was an order to abandon ship, which some did and some didn't. Some two hundred soldiers and sailors died in the water. For three days and nights, the *Uruguay* bobbed in the Atlantic Ocean before a United States destroyer rescued the survivors.

The future great football coach of Alabama spent over a year in Morocco. Writing home, Bryant expressed, "I hope I am lucky enough to bring you a German scalp. In any event, I shall give every effort to get the job done."

Many colleges did not field teams in 1943 due to World War II. Alabama would be one, as would Vanderbilt. The secretary of Vanderbilt's Committee on Athletics addressed a letter to Frank Thomas:

I am directed to inform you that Vanderbilt University does not anticipate having a football team of varsity caliber in the fall of 1943 due to the present emergency caused by World War II. Because of this situation, I am instructed to inform you that Vanderbilt University wishes to cancel its agreement with the University of Alabama, drawn up on the 20th day of March, 1939. You will understand that only this emergency, which has eliminated our football squad and coaching staff at Vanderbilt, would cause us to ask for this cancellation. We have been designated as an Army training institution, and there is no likelihood of these trainees being allowed to take part in intercollegiate competition. There may be some type of a football team representing Vanderbilt University composed largely of entering freshmen students, but in such event, we shall be hesitant to participate very much in intercollegiate competition, and in the interests of relieving transportation difficulties this competition would be limited to the local area. We had looked forward with a great deal of pleasure to this opportunity to meet the University of Alabama in intercollegiate competition, and we trust that when this present global struggle is over, this opportunity will be renewed.

Alabama would also decide to not field a football team in 1943. The University of Alabama *Alumni News* reported on this in the October 1943 issue:

The decision not to have any intercollegiate football this year for Alabama will strike a chord of regret in every heart. Many have hoped that a team could be put out even though it might not rank up with the famous stars of the past, but the inroads made by the Army, the Air Corps, and the Navy on the student roll have been particularly heavy at the University, and naturally fine athletes like members of our Tide teams are in great demand. This is the third time in history Alabama hasn't put out a football team, and we can afford to wait until things get back to normalcy.

Even though he would not have a football team to coach in 1943, Coach Thomas stayed busy. He headed War Bond drives all over the state to do his part in the war effort. He also recruited football players for whenever football resumed, hopefully in 1944. But he also traveled to recruit students,

not athletes, to come to the university that he loved so much. Coach Thomas was also active in civic affairs in and around Tuscaloosa, even serving as the Exchange Club president. He was a director of the City/National Bank of Tuscaloosa and a director for the Lincoln/Mercury automobile agency. Along with these duties, Coach Thomas helped to carry on an intramural sports program at the university.

There was a high school football player in Birmingham making quite an impression on colleges, and Coach Thomas attended several of his games in the fall of 1943. His name was Harry Gilmer of Birmingham's Woodlawn High School, and he would sign with the Crimson Tide and become one of the greatest players in Alabama football history.

One of the reasons that young Harry Gilmer signed with Alabama, other than the fact that he liked and admired Coach Thomas, was to follow his high school coach. Thomas and Malcolm Laney, Woodlawn's highly successful coach, were friends. Thomas had an opening in his staff and offered it to Coach Laney, who accepted. That pretty much sealed the deal for Harry Gilmer. He became Crimson, and to this day, few in Alabama's long, glorious football history have worn the Alabama uniform with more class and skill than Harry Gilmer.

One former Alabama football player had a great year on the gridiron in 1943. Don Hutson was an All-Pro with the Green Bay Packers, as he continued his Hall of Fame pro career as the most outstanding wide receiver in the NFL. Hutson caught forty-seven passes for 776 yards and eleven touchdowns, which was first in the NFL in all three categories. Hutson is regarded as one of the greatest players in Alabama football history and one of the greatest players in NFL history. Frank Thomas also considered Hutson the best player he ever coached.

Hutson would play eleven years for Green Bay, retiring in 1945. He was an All-Pro nine times, led the NFL in receptions eight times and was twice named Most Valuable Player, in 1941 and 1942. His ninety-nine career touchdown receptions stood as an NFL record for more than four decades. The Packers built an indoor practice facility in 1944 and named it the Don Hutson Center. Probably his greatest year was 1942, when he caught seventy-four passes for 1,211 yards and seventeen touchdowns. Oh, he also intercepted seven passes on defense and kicked three field goals and thirty-six points after touchdown out of thirty-six attempts. He also ran the ball six times for 41 yards and completed a pass for 38 yards and a touchdown. Other than that, he didn't do much!

17

"My Football Training Saved Me from Sure Death"

Hugh Miller played on the 1930 national title Crimson Tide team. In 1943, U.S. Navy lieutenant Hugh Miller credited Coach Wade with saving his life during World War II. Miller, then thirty-three years old, said that the "will to win" he learned during his playing days at Alabama helped him survive a forty-three-day stay against the Japanese on Arundel Island in the Solomons. From Tuscaloosa, Miller served as a gunnery officer on the destroyer *Strong*, which was sunk in Kula Gulf on July 4, 1943. Despite serious injuries from underwater explosions, he saved the lives of two men who were trapped against the side of the sinking ship and then joined sixteen other men on a life raft.

They drifted for four days, and when they landed on Arundel Island, only four were still alive. "There were Japs all around," Miller recalled. "I was losing so much blood I didn't think I had a chance to get through. I ordered the other three to take the equipment we had saved and go on. They did so reluctantly." Alone and bleeding badly, Miller lay on the ground and waited for death to come. "I was doing a lot of thinking," said Miller, "and I remembered what Coach Wade used to tell us—that if you believed you could win, nothing could stop you. I asked myself what the hell I was lying there for and began to feel better." Soon, the Japanese found his tracks on the beach and sent out patrols looking to capture him. Miller found some dead Japanese soldiers that had earlier been killed by an American P-T boat and stripped them of what equipment he could use. His old quarterback days at Alabama came into use once when he was cornered by a five-man

patrol. He threw a grenade right on target and killed all five. He took a bayonet and ran to the men to see if any were still alive; none was.

Miller remembered:

> *I got so I knew the jungle better than the Japs. I've hunted throughout Alabama, Mississippi and Louisiana and know how to live in the wilds. My football training, however, saved me from sure death, but I don't know how much good it would have done me if I hadn't played under Coach Wade. I think he is the greatest coach in the game.*

Miller continued to elude capture on the island until August 16, when he was rescued.

Earlier in 1943, before the Miller incident, Lieutenant Colonel Wallace Wade, then commanding officer of the 272nd Field Artillery Battalion, was recuperating from a broken leg suffered in training at Camp Butner, North Carolina. A reporter in Augusta, Georgia, had asked him, while Wade was getting treatment at Oliver General Hospital, about whether football would continue to be played during World War II. Wade told him:

> *I know of nothing that is a better preparation for a young man who is going into the army than football. The greatest benefit that football gives to a young man is that it teaches him to be a competitor, to never give up, to get back up after you're knocked down. Success in both football and war depends upon morale, loyalty and sound fundamentals.*

Miller was credited with killing up to fifteen enemy soldiers. He was awarded the Navy Cross, the navy's highest decoration for heroism. Eleanor Roosevelt presented Miller with the Navy Cross in a navy hospital.

In January 1957, Wallace Wade was asked to appear on the television program *This Is Your Life*. The show was about the life of Hugh Miller, who had requested that his old coach be there. On the program, Miller again credited Wade for his survival due mainly to Wade's "never give up" philosophy of life. A man of sixty-five years and one whose greatest loves in life were football and the military, Wade embraced Miller and modestly said that Miller had "a fighting spirit" in him from the time he came to Alabama to play football, and that was the reason for his surviving those horrid days eluding the Japanese in 1943 on that dense jungle island at the height of World War II.

18
COACH THOMAS GETS SICK

On November 30, 1939, Charley Boswell played his last game as a member of the Crimson Tide backfield when he starred in Alabama's 39–0 defeat of Vanderbilt on Dudley Field in Nashville, Tennessee. On November 30, 1944, exactly five years later, Captain Charley Boswell, 335th Infantry Regiment, 84th Division, 9th Army, was advancing with his unit in Germany when an enemy shell exploded nearby and seriously wounded him, ultimately costing him the sight in both eyes.

Boswell, who had played for Ensley High School in Birmingham, had enlisted in the army in 1941. To show Boswell how much he was appreciated, it was decided that there would be a game to close spring practice to raise money for Boswell. It was held on March 30, 1946. Coach Thomas heartily approved of the game to honor his former player. Tickets sold for one dollar, and the game, held at Legion Field, sold out.

Boswell developed a love of golf after going blind and became the most successful blind golfer in the United States, winning numerous golf tournaments for the blind. Boswell is now in the Alabama Sports Hall of Fame and the U.S. Blind Golf Association Hall of Fame.

Another former Alabama student, Mel Allen, went on to make quite a name for himself. Frank Thomas had chosen Allen to broadcast Alabama football games on the radio while Mel was a student in Tuscaloosa. In 1937, Allen was hired at CBS. Allen went on to become the "Voice of the New York Yankees" for many years. "How about that?" became his trademark exclamation point after Yankee home runs. Thomas, after

getting Allen started in his radio career, and Allen were close friends, especially considering that both were big baseball fans. Thomas was a lifelong Boston Red Sox fan and had played baseball and football at Notre Dame. Mel Allen passed away in 1996.

In 1948, Allen said of Coach Thomas:

> *Coach Thomas is more responsible than anybody else for my success. I loved much of the time with the coach and his family when I was a student at Alabama. He taught me much about sports. He criticized my work when I was broadcasting as a college student. He made suggestions, which were so helpful to me. He made the connections for me which led to my catching on in New York. Today, I regard Coach Thomas, and Mrs. Thomas, as the next thing to parents.*

By the time spring practice of 1946 rolled around, Coach Thomas noticed a definite loss of energy in himself. His doctor diagnosed high blood pressure and told Coach Thomas to curtail some of his activities. Not only was he busy preparing his team, but he was also a husband and father and was very active in the Tuscaloosa community. He was in the Exchange Club and headed drives for the March of Dimes and the Crippled Children's Clinic, among other activities.

Coach Thomas tried to cut back and stayed home a little more than usual during the summer months of 1946. During a coaching clinic in West Virginia in August, he noticed he was experiencing severe headaches each day, so after getting back home, he entered a Birmingham Hospital, where Dr. Joe Hirsch, his doctor, monitored him for close to three weeks. During the season, he would coach practices from an elevated platform on wheels that could be pushed around the field so he could watch and direct the players. He used a loud speaker because his voice was very weak at times.

But despite his physical ailments, Alabama started the 1946 season with four straight opening victories over Furman, Tulane, South Carolina and Southwestern Louisiana. But Tennessee beat the Tide in Knoxville 12–0. Alabama would lose three other games before beating Mississippi State in Tuscaloosa on November 30 in what would be Frank Thomas's last game as head coach.

Alabama finished 7-4 in 1946, a disappointment after being ranked number six in the AP preseason national poll. Harry Gilmer led Alabama in both passing yards and rushing yards while also returning punts for a team record 436 yards, leading the nation in that category. Hal Self

Frank Thomas had to coach from this trailer in 1946. Bad health from high blood pressure forced Thomas to resign after the 1946 season. Thomas won 115 games at Alabama, with only twenty-four losses, two national championships and four SEC championships. *Courtesy of Paul Bryant Museum.*

of the Crimson Tide won the Jacobs Trophy. Self would go on to an outstanding coaching career, serving as head coach at North Alabama for twenty-one seasons.

19

"We Just Beat The Hell Out of Those Boys"

The voice on the other end of the phone was that of an older man. "They gave me a car for playing at Alabama, but that rascal Harry Gilmer got two cars!" he said. "Coach Frank Thomas was one little tough SOB!" he replied to another question. Asked about the 1946 Rose Bowl win over Southern California, he said, "We just beat the hell out of those boys."

Before he passed away in 2011, I shared several phone conversations with Vaughn Mancha. I never met Mancha in person, but from reading about him and talking to him on the phone, I could tell this was a man who met life head on, full steam ahead. Also, he was one of the best to ever play football for the Crimson Tide.

Mancha was tough, and as most players did during his era in the 1940s, he played both offense and defense. He was a center and a linebacker. "I played sixty minutes all the time. And I didn't get any breaks or any water or Gatorade, like these babies today. It would be 150 degrees in August, and Coach Thomas wouldn't give us water back then. If I could have just gone in on defense, boom, boom, boom, and then taken a little rest, drank a little water, I'd have been pretty good," Mancha chuckled. Well, he was pretty good as it was, being named All-American, being named to Alabama's All-Century Team and being selected to the College Football Hall of Fame.

The reference in the first paragraph to Harry Gilmer, the great quarterback and Mancha's teammate, about getting two cars to his one was meant in jest, as I learned Mancha was fond of doing. He had all the respect in the world for Gilmer, but when asked about the gifted quarterback, Mancha again

Getting dressed for a game are, from left to right, Lowell Tew, Vaughn Mancha and Harry Gilmer in 1945. Mancha and Gilmer were first team All-Americans, and Tew led the Tide in rushing with 715 yards. The 1945 team finished ranked second in the country to Army, going undefeated at 10-0 and beating Southern California 34–14 in the Rose Bowl. In this season, Harry Gilmer became the first Alabama player to run for more than 200 yards in a game, getting 216 against Kentucky. *Courtesy of Paul Bryant Museum.*

reverted to form: "I made Gilmer great. I protected him, knocked people off of him so he could get all the glory."

Recalling the 1946 Rose Bowl win over Southern Cal, Mancha said:

> *It was just one of those days that seemed like we just ran all over them. They had the biggest, prettiest people I had ever seen. What really stands out in my mind, I was six-one, 235 pounds. They had tackles that went up to 290, big, beautiful muscle beach boys with duck cuts, but they didn't know how to run. We just had a magnificent day. Anyway, it was such a great thrill, and of course, seeing all of the pageantry and all the things, like Johnny Mack Brown, who had played at Alabama and was now a big cowboy movie star, takes us out to a big ranch and we see a rodeo. We went to the San Anita Race Track and to Warner Brothers Studios.*

Asked about his coach, Frank Thomas, Mancha replied:

Coach Thomas is certainly one of the great coaches of all time and probably answered the call better than I've ever seen anybody do when he succeeded Wallace Wade at the university. He was a magnificent man. He was a man that didn't really say a lot, but the little talks that he would give you had great substance. He influenced me a great deal. I really began to appreciate Coach Thomas when I went into coaching. I used to come up and talk to him when I was head coach at Livingston. Then I began to realize what a smart man he really was.

I knew Bear Bryant, and I idolize him; he was one of the great coaches. But we also had the great Wallace Wade and Frank Thomas, who laid greatness on Alabama. Of course, there was only one Bear Bryant, make no mistake. He was a man with great charisma. He had such presence. He'd walk into a room, you could feel it.

Drafted in the first round in 1948 to the Boston Yanks of the NFL, Mancha tore his anterior cruciate ligament and only played two seasons of NFL ball. He went into coaching, including being an assistant at Florida State, where he served as athletic director from 1959 to 1974.

20

COACH HAROLD "RED" DREW

Harold "Red" Drew became head coach of Alabama in 1947, succeeding Frank Thomas. From the 1947 season through the 1954 season, Drew won fifty-five games with twenty-nine losses. Drew took Alabama to the Sugar Bowl, Cotton Bowl and Orange Bowl. In the 1953 Orange Bowl, Alabama beat Syracuse by a score of 61–6. Alabama won the Southeastern Conference championship in the 1953 season. He had been a longtime assistant coach to Frank Thomas and had tutored outstanding ends like Bear Bryant, Don Hutson and Holt Rust during their playing days at Alabama.

In that first season of 1947, Alabama beat Kentucky 13–0 in Lexington. Kentucky was coached by none other than Bear Bryant, who had been a player at Alabama from 1933 to 1935, when he lettered. Red Drew had been an ends coach and played a huge role in the development of Bryant and Don Hutson, who were teammates. Herb Hannah, a player on the 1947 Alabama team, remembered looking across the field at Bear Bryant on the opposite sideline: "Coach Bryant was a young man, and he had a physique at the time that made him look like a giant. He looked like he had shoulder pads on. He came to our hotel the night before the game to visit Coach Drew, and somebody said, 'There's Coach Bryant.' I felt chills run over me. His presence, even then, was enormous."

I had the pleasure of visiting with Polly Drew Jansen, Red Drew's daughter, in her residence in Tuscaloosa on a couple of occasions. Ms. Drew is a 1944 University of Alabama graduate. She, of course, remembers her father more as a loving, caring parent than as a famous football coach but

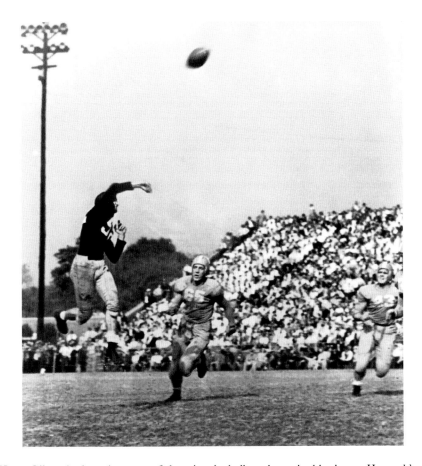

Harry Gilmer had a unique way of throwing the ball, as shown in this picture. He would leap in the air before releasing the ball. But throw he could, along with just about anything Alabama needed, in his playing days of 1944 to 1947. He ended his career as the leading rusher (1,673 yards) and passer (2,894 yards) and in punt returns for average, kickoff returns for average and interceptions. He passed for twenty-six touchdowns and ran for twenty-four touchdowns. *Courtesy of Paul Bryant Museum.*

also still retains vivid memories of those days living in Tuscaloosa as the daughter of the most recognized man in town. All Alabama head coaches have that distinction during their coaching tenure.

The year 1948 saw the resumption of the Auburn game. These two rivals had not played since the 1907 season. Alabama whipped the Tigers 55–0 as Ed Salem put on quite a show. Salem threw three touchdown passes, one to Rebel Steiner for fifty-three yards, and ran for a touchdown as well. Not to be done for the day, Salem kicked seven extra points.

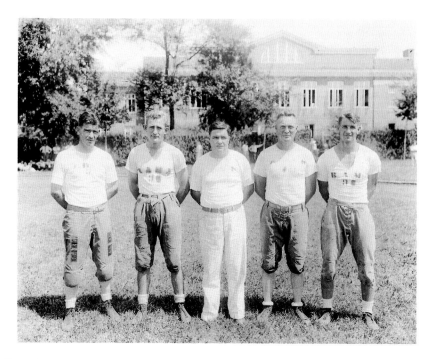

From left to right: Hank Crisp, J.M. "Ears" Whitworth, Frank Thomas, Red Drew and Johnny Cain. Crisp was a longtime assistant coach at Alabama—from 1921 to 1942 and from 1950 to 1957—and worked in some capacity at Alabama until 1967, including as athletic director. He was basketball coach from 1924 to 1942 and again in 1946, compiling a 264-133 record. Crisp lost his right hand at age thirteen in a farm accident but had an outstanding playing career at Virginia Tech. Whitworth was head coach at Alabama from 1955 to 1957, Thomas from 1931 to 1946 and Drew from 1947 to 1954. Cain was an All-American running back three years in a row, in 1930, 1931 and 1932. *Courtesy of T.J. Weist.*

Salem went on to a stellar career in Tuscaloosa before being drafted by the Washington Redskins in 1951. He intercepted five passes in his rookie season. After a very successful business career, Salem passed away in 2001. He was inducted into the Alabama Sports Hall of Fame in 2012.

Alf Van Hoose, famous *Birmingham News* sportswriter, wrote about a typical day in the life of Red Drew in 1948. Van Hoose followed Drew around all day from morning to night and listed what Drew did:

> *Ate breakfast with wife, Marion, and son Bobby, who is a graduate student of Alabama.*
> *7:42: The Greensboro Quarterback Club calls and asks Drew if he can be a guest speaker.*

Red Drew sits atop the new car he was given by Alabama supporters. Drew won fifty-four games with twenty-eight losses from 1947 to 1954 as Alabama head coach. He had been an assistant coach at Alabama from 1931 to 1941 and again in 1945. *Courtesy of Polly Drew Jansen.*

8:20: Bobby drives Coach Drew to the office in their family car, 1949 Chevrolet.

8:34: Drew opens mail. Has over ten letters waiting for him on his desk.

8:40: Dictates letter to Athletic Office Secretary Mary Hocutt.

8:56: Takes phone call.

9:01: Drew and his coaches, Hank Crisp, Malcolm Laney, Tom Leib, Lew Bostick, and Happy Campbell, meet in conference room. They watch movie of last week's game against Tulane.

11:55: Drew calls off session.

12:03: Bobby arrives and takes Dad to lunch at Pug's Restaurant. Drew speaks to several other patrons. Alabama's publicity director joined Drew and Bobby for lunch, then discuss the upcoming Vanderbilt game.

1:30: Meets with coaches and team to go over film of Tulane game.

2:17: Players leave, coaches continue discussion of game film.

3:00: Drew walks on Denny Field for practice.

3:32: Blows whistle, calls for group work. Walks from group to group for instruction.

3:59: Blows whistle. Team scrimmages.

5:42: Blows whistle. Team runs wind sprints.

6:10: Arrives home for dinner.

7:15: Goes back to office for staff meeting. Practice for the day is discussed. Vanderbilt game plan is talked about

11:30: Meeting over. Heads home after a long day.

21
HOOTIE

After spending almost two hours with Cecil Ingram in the lobby of the Capstone Inn on the Alabama campus, I felt I had learned more about Crimson Tide football than I had the entire day spent looking at microfilm, old yearbooks and alumni magazines in the Hoole Library across campus. That's no knock on the library because it has a lot of resources to use if you have an interest in Alabama football like me. But Cecil Ingram has a wide knowledge of football at Alabama.

Some people around Tuscaloosa might just hesitate if they are asked if they know Cecil Ingram. But if you ask them if they know Hootie, chances are mighty good that they will know the man.

Ingram grew up in Tuscaloosa and lived near Alabama head coach Frank Thomas; he was a good friend of one of Coach Thomas's sons, Hugh. He hung around practices as a youngster, learning football from the likes of Tide All-American Harry Gilmer.

I didn't ask Hootie if another "extracurricular activity" of his youth growing up in Tuscaloosa was the robbing of birds' nests. The June 1, 1937 issue of the *Tuscaloosa News* had this editorial:

> *Two or three of the good women of Tuscaloosa have solicited our help in an effort to stop the robbing of birds' nests by young boys—and we are glad to give it, even though we think that the hair brush in a parental hand will be a more effective cure for this sort of behavior*

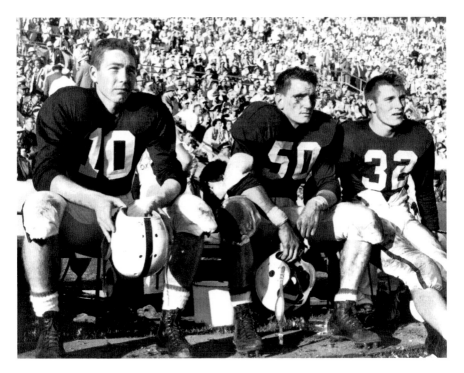

Shown is Bart Starr on the left, Ralph Corrigan in the center and Bobby Marlow on the right, from the 1952 season. Bobby Marlow, a halfback, led Alabama in rushing for three straight years in 1950, 1951 and 1952. Starr's best season was 1953, when he passed for 870 yards. Starr wasn't drafted until the seventeenth round by the Green Bay Packers, but he went on to a Hall of Fame career with the Packers, winning two Super Bowls. *Courtesy of Paul Bryant Museum.*

than a protest on the editorial page. It is hard to imagine how a bunch of boys can be so brutal as to jerk helpless fledglings from the nests of our songbirds.

Hootie was a three-sport standout at Tuscaloosa High School before becoming a two-sport star athlete at the University of Alabama in football and baseball. He was an Alabama letterman in both sports from 1952 to 1954. He played football for Red Drew. As a sophomore in 1952, Hootie led the nation in interceptions, with ten, returning two for touchdowns. He also led the Southeastern Conference in punt return yardage and ran a punt back eighty yards for a score in Alabama's 61–6 win over Syracuse in the Orange Bowl. In 1953, Ingram shared quarterback duties with Bart Starr, the future All-Pro quarterback of the Green Bay Packers.

After his playing days, Hootie Ingram became a football coach. He coached at Brookwood High School in Tuscaloosa County and also served as an assistant coach at several colleges. He eventually became head coach at Clemson. In 1980, he became athletic director at Florida State. And in 1989, Hootie Ingram came back home, accepting the athletic director's job at Alabama.

I asked Hootie for some of his thoughts on Alabama football:

> *Frank Thomas was a master psychologist. He was always looking for an edge. He really stressed precise fundamentals. I remember he once told us we were going to a local park to see the "best baseball player in the country." Willie Mays tripled his first time up. Coach Thomas really loved baseball. Even before Hank Aaron was well known, Coach Thomas said Aaron had the "quickest wrist I've ever seen on a baseball player." Coach Thomas, after he got sick, would park near the end zone so he could watch home football games. Every Thursday at 7:00 p.m. during my sophomore year, 1952, we would sit down and talk about personnel and game plans. I learned so much from him.*

Among his many accomplishments, Hootie Ingram is now enshrined in the Alabama Sports Hall of Fame, and he was chosen as a defensive back on the Alabama All-Century Team.

22

"MAMA CALLED"

The loss in the last game of the 1957 season sealed the fate of Alabama coach J.B. "Ears" Whitworth, who had a combined 4-24-2 record in his three seasons, from 1955 to 1957. Auburn beat Alabama 40–0 in front of forty-three thousand fans at Legion Field in Birmingham. As one sportswriter proclaimed, "The massacre of the Crimsons was thorough, complete, and highly satisfying for the Auburn fans." As for Alabama fans, who were used to winning national titles, conference championships and bowl games under coaches such as Wallace Wade, Frank Thomas and Harold "Red" Drew, their hopes now turned to a former Crimson Tide player and assistant coach, one Paul "Bear" Bryant.

Bryant was the head man at Texas A&M, where he had compiled a record of 25-14-2 in four seasons, including a 17-3-1 record in his last two seasons, 1956 and 1957. Before that, he had coached Kentucky from 1946 to 1953, winning sixty games with twenty-three losses, which included Sugar Bowl and Cotton Bowl victories. He had coached one season at Maryland and went 6-2-1 before realizing Adolph Rupp and basketball would always be top dog in Lexington. So Bryant was 91-39 as a head coach and had been a good player and assistant coach at Alabama under Frank Thomas. Speculation centered on his being offered the job in Tuscaloosa.

Other coaches rumored to be "in the mix" for the Alabama job were UCLA's Red Sanders, Oregon State's Tommy Prothro, SMU's Bill Meek and North Carolina's Jim Tatum, among others. Former Bama players Harry Gilmer and Johnny Cain were also mentioned. But the number one

choice, hands down, was the Bear, and the pressure was immense. When asked if he had been contacted by Alabama, Coach Bryant said, "All I can tell you is that I've had a million calls from my Alabama friends."

Mae Martin Bryant, Coach Bryant's twenty-one-year-old daughter, gave a strong hint that her father would accept the job when she told a local writer that "Mama said I could call you and tell you that we were looking forward to being back home together in Alabama soon." When contacted, Coach Bryant, who still had a game to play against rival Texas, replied, "All I'm thinking about right now is the Texas Longhorns. I imagine they're thinking about us too. We play them Thursday."

After the Texas game, of course, the first question Coach Bryant got was about the Alabama job:

> *Alabama is my school, and if I was convinced I could help, I certainly would consider it. When you are out playing as a kid, as I did, and say you heard your mother call out. If you thought she just wanted you to do some chores, you might not want to answer her. But if you thought she needed you, you'd be in a hurry. I feel the same way about this. If I really felt Alabama was in trouble and needed me, I'd go back there in a hurry.*

Well, "Mama" (Alabama) did call out in need to her boy, and after accepting the job, Coach Bryant, when asked why he had done so, made his famous reply, "Mama called."

Bear Bryant believed in hard-nosed football, and things were about to change around Alabama football. He was ready, and he knew that football was something few men could coach as he did. As he told alumni after accepting the Texas A&M job, "Up to now, we've had too many chiefs and not enough Indians around here. From now on, I'm the chief and you're the Indians. I know how to coach football. You may think you do, but I know I do. So I don't need your advice."

Bear Bryant first met with his new team on December 9, 1957, in Friedman Hall. After he had talked to the players, they were dismissed. On the way out, Alf Van Hoose, sportswriter for the *Birmingham News*, asked a couple of players how it went. One replied, "That man is a big leaguer." The other young man simply said, "Everything's going to be all right around here now."

23

THE BEAR IS BACK IN TUSCALOOSA

Bear Bryant won his first game as head coach at Alabama on October 11, 1958. The victim was Furman by a 29–6 score in Denny Stadium. Bobby Jackson, the Crimson Tide starting quarterback, ran for one touchdown. Not to be outdone, second-string quarterback Bobby Smith came in and threw for two touchdowns, one a sixty-one-yarder to halfback Gary O'Steen.

After the game, Coach Bryant said, "We're just as happy over the win as if it had been a win in the Rose Bowl. Any win, by any score, and we are happy." The win made the Bear's record at Alabama 1-1-1, after an opening game loss to LSU and a tie with Vanderbilt in the second game of the season.

Soon after the win over Furman, however, two players decided to "quit football at Bama." Billy Rains, a senior guard, and Ferdy Cruce, a sophomore halfback, "after consultation with me, decided to concentrate on their studies," announced Coach Bryant. Their departure reduced the Alabama squad to forty-one players, twenty-three fewer than the original sixty-four who had started fall practice. The returning players had heard about the tough reputation of Bryant, but this Bear was even more ornery than they had been told.

Coach Bryant recalled that first year in Tuscaloosa:

I never had a doubt that we would win at Alabama. I just didn't know how long it would take. The team that I inherited was a raggedy bunch.

The best players quit on us. At a meeting, I said, "What are you doing here?" And I waited. It was so quiet you could hear the boys breathe. Then I yelled, "If you're not here to win the national championship you're in the wrong place!"

Well, Bear Bryant didn't win a national title that first year in 1958, but opponents around the South sure realized that Crimson Tide football would soon be a force to be reckoned with. Wins over Furman, Mississippi State, Georgia, Georgia Tech and Memphis State gave Alabama a 5-4-1 season record. Yes, one of the losses was to the Tigers of Auburn, by a 14–8 score in Birmingham. But Bear Bryant would have many victories over Auburn, and other teams, in the years to come.

24

GLORY YEARS FOR THE TIDE

1960s and 1970s

I have been a fan of Alabama football ever since I was a young boy. I used to enjoy listening to Bear Bryant on television in the 1960s and '70s say before a big game, "Aw, I'm not sure we stand much of a chance against those big boys; they're a lot bigger than my 'little old skinny things.' I hope we can just keep from getting embarrassed out there on Saturday." Of course, these words were for writers and forecasters to do with what they wanted and for the opposing team to build some overconfidence.

What happened almost every Saturday in the '60s and '70s was that Bear Bryant's "little old skinny things" would go out on the field and put a whipping on the opponent. While Coach Bryant was downplaying his team's chances to the public to some extent, his players knew he believed in them, and they believed they could and would beat anybody in America who had the audacity to line up next to them.

Bear Bryant won everywhere he played or coached football. I mean, you can go all the way back to his high school teams in Fordyce, Arkansas. The team was called the Redbugs, and they won the state championship in Bryant's senior season, 1930. J. Willard Clary, who covered Fordyce football for the *Arkansas Gazette*, wrote about one of the reasons for the success of the Fordyce Redbugs: "South Arkansas is covered with pine thicket and the main sport of the boys is rabbit hunting. When they go out rabbit hunting, the fast boys sidestep and dodge through the pine saplings. They make good back field men. The slower boys run over the pines. They make good linemen."

WE'RE NUMBER ONE

Bear Bryant won his first national title at Alabama in 1961. Alabama went 11-0 and beat Arkansas 10–3 in the Sugar Bowl. Billy Neighbors, Lee Roy Jordan and Pat Trammell were named All-Americans. Only twenty-five points were scored on Alabama in eleven games. North Carolina State scored seven points, the most by any team. Lee Roy Jordan is seated on the left. Jordan would have thirty-one tackles in the 1962 Orange Bowl win over Oklahoma. *Courtesy of Paul Bryant Museum.*

Well, young Paul Bryant was a big one for the time (1930). He was a giant for a high school boy, standing six-foot-three and weighing 190 pounds. But he was quick to boot. He was one of those rare south Arkansas boys who, when out rabbit hunting, could dodge through or run over the pine saplings.

Bryant's size and star play for the Redbugs got him a ride in the rumble seat of Alabama assistant coach Hank Crisp's Ford roadster in the summer of 1931 to the University of Alabama campus. The Crimson Tide, fresh off the 1930 national championship under Wallace Wade, wanted this big strapping young man to play football in Tuscaloosa. In the three years that Bryant lettered at Bama, from 1933 to 1935, the Tide won twenty-three games, with only three losses, and won the 1934 national title under coach Frank Thomas.

Bear Bryant won six national titles and thirteen SEC champoinships during his legendary career at Alabama. *Courtesy of Paul Bryant Museum.*

Bryant's winning habit continued as a head coach; he won at Maryland, Kentucky and Texas A&M before "Mama called" him back to Alabama in 1958.

But let me get back to the '60s and '70s, when I started to root for Crimson Tide football. Now, this statement might mean more if I let you know I grew up in tobacco country near a town of about eight thousand, Oxford, North Carolina. Not too far down the road from Oxford are Durham and Raleigh.

There were two things that were topics of discussion where I grew up: tobacco and basketball. Tobacco built just about all the towns in the area, and if you drove into these towns in the '60s and '70s, you would pass huge tobacco warehouses. If you had your window down, the sweet aroma of tobacco would greet you. The other thing we absolutely loved in North Carolina was our college basketball. Goodness, powerhouses Duke and North Carolina were only about ten miles apart, and to our way of thinking, nobody in America played basketball better. North Carolina State had some great teams, as well, along with Wake Forest. Football, to many, was a sport to be tolerated until the round ball sport came along each winter. Just

What Of The Future?

At the close of the 1964 season, Paul Bryant's teams had won 60 games in seven years for the University of Alabama, and Bryant had won 150 contests in his career as a head coach. Both are remarkable records.

The Bryant Era already has contributed greatly to Alabama's rich football tradition. No one doubts that more is to come.

ROLL, TIDE!

PAUL CRANE
Pre-Season All American

Bear Bryant takes the field in 1964, when Alabama won its second national title under him. From 1960 to 1967, Bryant was 76-8, a remarkable run of domination. The run included three national titles and four SEC championships. *Courtesy of Paul Bryant Museum.*

like little boys in Alabama dreamed of playing football at Alabama under Bear Bryant (and maybe a few even dreamed of playing for Shug Jordan at Auburn), little boys in North Carolina in the '60s and '70s shot hoops in their backyard with visions of playing for Vic Bubas at Duke, Dean Smith at UNC or Norm Sloan at North Carolina State.

But in the midst of all these green fields of tobacco and basketball-crazy people, I somehow started liking Alabama football, way down in Tuscaloosa, what I call the Deep South from my North Carolina vantage point. And growing up in the '60s and '70s, I couldn't have pulled for a bigger winner.

Just think of this: from 1960 through 1967, an eight-season period, Alabama, under Coach Bryant, won seventy-six games against eight losses, with three national titles. From 1971 through 1979, a nine-season span, Alabama won ninety-seven games against eleven losses, with three more national titles.

What may be even better to Alabama fans is that Coach Bryant just made a habit of spanking Auburn. During the two eras I cite, from 1960 to 1967

Bear Bryant assumes one of his favorite positions before a game, leaning against a goal post. *Private collection.*

and 1970 to 1979, Alabama beat Auburn fifteen times, with only two losses. In his twenty-five seasons at Alabama, Coach Bryant went 19-6 against Auburn in the Iron Bowl.

Maybe Bum Phillips said it best about the coaching prowess of Coach Bryant: "He can take his'n and beat your'n and then take your'n and beat his'n."

Back in 2006, I was teaching a couple courses at Duke University in the Physical Education Department. I was also writing a weekly column for the *Durham Herald-Sun*. I decided to write a biography of Wallace Wade, who had

Even opposing teams' cheerleaders wanted to meet the famous Alabama football coach. The young Tennessee ladies pictured here are all smiles, as one even dons Bryant's houndstooth hat. *Private collection.*

won three national titles at Alabama before becoming head coach at Duke. Coach Wade also had great success at Duke, and the football stadium there is now called Wallace Wade Stadium. So of course, since a biography to me is writing about a person form birth to death, I knew that Coach Wade's Alabama years should be included, and off I went to Tuscaloosa. I have spent quite a few days in the Bear Bryant Museum wrestling with scrapbooks about three feet long and ten inches thick, or so they seem. They are so big that when you lay them down on a table in front of you, you have to stand to read the top of the page. But Crimson Tide football history comes alive in these pages, along with the Bryant Museum's many other resources.

I soon realized, since Alabama was football country, Wallace Wade was revered probably more in Alabama than in North Carolina. And since the publication of the book *Wallace Wade: Championship Years at Alabama and Duke*, I have often called Tuscaloosa my second home, as I've made several trips to Tuscaloosa and around the state sharing the story of Wallace Wade to Crimson Tide fans.

Writing about Wallace Wade has also made me an even bigger fan of Alabama football and has involved me in the sport much more. I have written articles for *Bama Magazine*, *Alabama Alumni Magazine* and the Alabama Online Encyclopedia and now have written this book.

Left: Bear Bryant and Wallace Wade are shown together as Coach Bryant neared retirement in 1982. Next to Bryant's six, Wade is second on the list of most national titles as Alabama head coach, with three. *Hoole Library, University of Alabama.*

Below: Reggie Jackson, the famous slugger of the New York Yankees, meets Bear Bryant. *Courtesy of Paul Bryant Museum.*

I have enjoyed signing books in the Bryant Museum and on the quad before home games and speaking to Quarterback Clubs, such as in Tuscaloosa and Selma. A real pleasure was speaking about Coach Wade in Monroeville, home of Harper Lee, author of *To Kill a Mockingbird*. Being interviewed on the Alabama Radio Network was nice, along with quite a few other radio and television stations. I've met some of the big names associated with Alabama football, such as Mal Moore, Alabama athletic director and former assistant coach for Bear Bryant; Clem Gryska, longtime assistant to the Bear; former Crimson Tide player and athletic director Hootie Ingram; and former players such as Barry Krauss, T.J. Weist and Don Salls. I also had the pleasure of several phone conversations with Alabama greats Harry Gilmer and Vaughn Mancha, among others. I sat for two hours in a Cracker Barrel restaurant with Frank Thomas Jr., son of the great Alabama coach Frank Thomas, and have become friends with Polly Drew Jansen, daughter of former Tide coach Red Drew. I have enjoyed getting to know Alabama graduate David Cutcliffe, now Duke's head coach. Coach Cut, as he is affectionately called, is a big fan of Wallace Wade and Bear Bryant and wrote a foreword for my Wallace Wade book. I was honored to be asked to give the induction speech for Wallace Wade a couple years ago when he was inducted into the Southern Conference Hall of Fame, of which Alabama was a member before joining the Southeastern Conference.

With two of the last three national titles for Alabama under Nick Saban, Crimson Tide football continues to be among the nation's elite programs. And one person who will be watching and cheering for the Crimson Tide will be this writer, who grew up hundreds of miles away in tobacco and basketball country. Roll Tide!

"Nobody, I Mean Nobody, Ever Climbed the Tower Except Coach Bryant"

Joe Namath was a coveted high school quarterback from Beaver Falls, Pennsylvania. He made a visit to Tuscaloosa in December 1960, and he arrived on campus as Alabama was practicing for a bowl game against Texas. Namath recalled the visit:

> *Coach Bryant was up in the tower, watching and frowning and yelling. Then he waved his arms up at me, so I climbed up in the tower with him. He introduced himself. I introduced myself, and we started talking. I didn't know what in the hell he was talking about. We must have talked for fifteen minutes, and out of the whole conversation I don't think I understood one word. I had to get used to that southern way of speaking he had.*

An Alabama player, Cotton Clark, remembered Joe scaling the tower. "I knew Joe had to be a good player because his first trip to campus, Coach Bryant invited him up in the tower. Nobody, I mean nobody, ever climbed the tower except Coach Bryant. And Joe had confidence written all over him, even then."

Joe played with the freshmen team in 1961, the year Alabama won its first national title under Bear Bryant. Pat Trammell was the Tide quarterback. In 1962, Namath took the reins, but Coach Bryant tried to lower expectations for the highly touted young quarterback. "Joe has worlds of talent. The big question about Namath is not his ability, but can he beat people like Trammell did? Heck, Joe hasn't even gotten his feet wet yet."

Ray Perkins (left) and Joe Namath (right) play against Auburn in 1964. Namath had an outstanding career at Alabama before becoming a national celebrity as quarterback of the New York Jets. Perkins went on to become the man who succeeded Bear Bryant as Alabama head coach in 1983. Perkins was 32-15 in four seasons before leaving to become head coach of the Tampa Bay Buccaneers in the NFL. *Courtesy of Paul Bryant Museum.*

On September 22, 1962, Joe Namath not only got his feet wet but also dove right into Alabama lore as he threw for three touchdowns in his debut, a 35–0 win over the Georgia Bulldogs. He completed ten of fourteen passes for 179 yards. After the game, even Coach Bryant, who could find fault in any player or team, said, "The quarterbacking is in real good hands with Namath on the scene."

Alabama finished 10-1 in 1962, beating Oklahoma in the January 1 Orange Bowl. Namath threw for thirteen touchdowns, which were a lot for back then. The only loss that year was to Georgia Tech.

In 1963, Namath was suspended for two games because he had been spotted carousing with some teammates. So he sat out the final regular season game and the Sugar Bowl. "In the long run, it made a very positive impact on me. Rules are rules, and they're not made to be broken. Coach Bryant did the right thing, and I had to accept it and learn from it and move on."

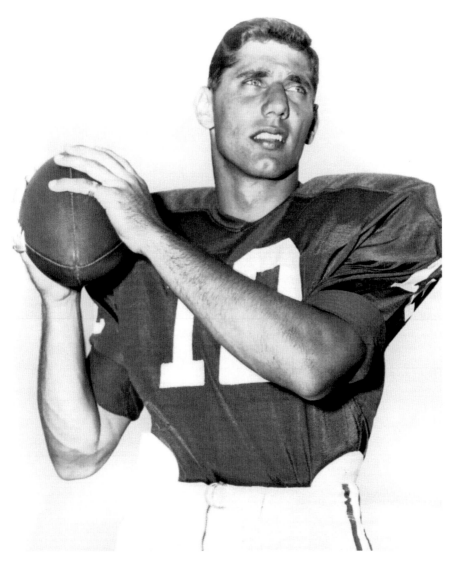

Joe Namath is shown during his days as the Alabama quarterback. Namath helped to lead Alabama to a 29-4 record in his three varsity years of 1962, 1963 and 1964 and a national title in 1964. *Courtesy of Paul Bryant Museum.*

Another incident had happened in 1962 that Namath learned from. Namath was pulled from a game against Vanderbilt after some sluggish possessions by the Tide offense. Joe was frustrated and flung his helmet down to the ground after he came off the field. To his horror, the helmet rolled right in front of Bryant's feet. "He looked at it calmly," Namath recalled,

> *without any expression, and then he came over and sat down next to me on the bench and draped an arm around my shoulder. There were fifty thousand fans in the stands, and it must have looked as though he was giving me some fatherly advice or cheering me up. But what he was doing was squeezing the back of my neck with one of those big hands of his. He was saying, "Boy, don't ever let me see you coming out of a ballgame like that. Don't ever do it again, or you're gone."*

Namath came back in 1964 to lead Bama to a 10-1 record and the national championship. Steve Sloan played valuable quarterback minutes in 1964, as well, as Namath got banged up.

Joe Willie, as he began to be called at Alabama, went on to become Broadway Joe of the New York Jets.

As an author, you enjoy signing books and meeting people who are interested in the same subject you are. My Wallace Wade book came out in 2006, and I was asked to sign the book at the Bear Bryant Museum before a home game in Tuscaloosa. Of course, I accepted the invitation and looked forward to it. Then, John McGaugh, who coordinated the book signings for the university, told me that another author (as usual) would be signing with me in the museum, and that author would be Joe Namath. I got to thinking and was at first excited about it. I even told myself that I would go over and meet Joe and buy his book. But then a frightening thought occurred to me. I could just imagine the scene: the famous Joe Namath sitting behind his table with a line of people about a mile long, and there I would be, close by, sitting behind my table with nobody in line. A week or so later, John called me and said Joe had a scheduling conflict and would have to come at a later date. Or was it that Joe Namath didn't want to go head-to-head with me? I think we all know the answer to that one.

My wife, Beth, really brought me down to earth after I told her of my worries about signing books with Joe Namath. Her reply was, "Oh, Lewis, even if you don't sell a single book, I want to meet Joe Namath!"

26

"These Little Ole Skinny Things"

1965

One of the most satisfying wins over Auburn for Alabama had to be the 1965 game. Quarterback Steve Sloan led the way as Alabama beat Auburn 30–3, clinching the Southeastern Conference Championship in the process. Sloan threw three touchdown passes, and the Crimson Tide defense set a team record with seven interceptions. The old record had been six against Howard in 1938. In fact, Auburn threw more interceptions to Alabama than it completed to Auburn. Auburn had six pass completions all day. Alabama's Sloan completed thirteen of eighteen, for 226 yards, to go with the three touchdowns. Ken Stabler came in and completed both of his passes for 22 more yards. After the game, Coach Bear Bryant praised Sloan: "I think Steve Sloan is the finest college passer in America. I know he's the most accurate I've ever been around."

One of the reasons for the success of the 1965 team was the outstanding assemblage of assistant coaches who worked under Bryant. Howard Schnellenberger would go on to an outstanding head coaching career, as would Pat Dye; another assistant, Clem Gryska, would serve Bryant loyally for many years, and the staff also included Jim Sharpe, Richard Williamson, Sam Bailey, Ralph Genito, Ken Donahue, Duke Hennessey and Ken Meyer. Also serving as an assistant was Mal Moore, who is now the athletic director at Alabama.

On January 1, 1965, Alabama won its third national title in five years by beating Nebraska 29–28 in the Orange Bowl. The end of the 1961 and 1964 seasons had seen the Tide also crowned the best in the nation.

Steve Sloan completed twenty passes for 296 yards. Ray Perkins, who would one day be chosen to succeed Bear Bryant as Alabama coach, caught ten passes, setting an Orange Bowl record. Leslie Kelley ran for 116 yards for Bama.

Asked after the game about his boys, who were outweighed by an average of thirty-five pounds up front, Bryant responded, "These little ole skinny things sure have big hearts."

Steve Sloan completed 97 of 160 passes for 1,453 yards and ten touchdowns for the 1965 season, with only three interceptions. Sloan had been the backup quarterback to Joe Namath in the 1963 season but started in 1964, when Namath was injured. In the 1965 Orange Bowl against Texas, Namath came in for Sloan and won game MVP honors. The very day after that game, Namath signed for a then magnificent salary of $400,000 a year with the New York Jets of the American Football League. Namath went on to a great career with the Jets from 1965 to 1976, and he played one season, 1977, with the Los Angeles Rams.

After the 1965 season, Sloan was drafted by the Atlanta Falcons and played for two seasons. In 1973, he became head coach at Vanderbilt. In 1975, Sloan accepted an offer from Texas Tech to become head man, where he was 23-12 in three seasons. He coached at Old Miss from 1978 to 1982, when he became the coach of the Duke Blue Devils. Sloan, after his coaching days, served as the athletic director at Alabama.

27

THE TIDE RISES AGAIN

1971

The 1969 and 1970 seasons were not good for Alabama football, not by usual Crimson Tide standards. Alabama was 6-5 in 1969 and 6-5-1 in 1970. A three-game stretch that spanned the two seasons was among the worst three games Bear Bryant and Alabama ever endured. In the last regular season game of 1969, Auburn beat Alabama 49–26. In its next game, in the Liberty Bowl, Colorado beat the Tide 47–33. Then, to open the 1970 season, Southern California steamrolled Bama 42–21. Three-game losing streaks just didn't happen to Bear Bryant–coached Alabama teams; it had never happened. From 1960 to 1968, Alabama had won eighty-four games with only eleven losses. That's eleven losses in nine seasons, understand.

The loss to USC was just plain embarrassing. Not only did the Trojans put a whipping on Alabama, but they did so right in Legion Field in Birmingham, Crimson Tide turf. Some seventy-two thousand witnessed the butt-whipping. The USC men were bigger, faster, stronger and meaner than the Bama boys. It was clear for all to see. Bryant praised USC's John McKay: "He had his team well prepared and took advantage of our many weaknesses."

The Trojans amassed 485 yards, and that was not total yards; the 485 was on the ground. Most of the damage was done by six-foot-three, 215-pound Sam "Bam" Cunningham, who got 135 yards on just twelve carries. Sam was big and black, and some to this day say watching Cunningham run roughshod over his team that day convinced Bryant it was time to change the racial makeup of the Crimson Tide.

Bear Bryant earned his nickname by wrestling a bear as a youth, with the trademark houndstooth hat added much later.

Things didn't get much better in the 1970 season after the loss to USC, as Alabama lost four more games. Bear Bryant wasn't used to all this losing; he was determined to put a stop to it, and he did. From 1971 to 1979, Alabama would win ninety-seven games against eleven losses. But the turnaround began with the 1971 team.

Before the 1971 season opener, Bryant installed the wishbone offense. Bryant, in an interview after the 1971 season, gave his reasons for the change: "We weren't winning with what we were doing, so we had to go to something different. I went to Dallas to talk to Darrell Royal (the Texas coach who popularized the wishbone). Then Darrell came to Tuscaloosa to give a clinic. I made up my mind. We were going to the wishbone."

The opponent to open the '71 season was none other than Southern Cal, which had inflicted that 42–21 beating on Bama in 1970. This game was played on USC's home field in California. Alabama got sweet revenge, beating the twelve-point favorites 17–10.

It was one good day for Coach Bryant, as not only did he avenge the loss to the Trojans but also the win was his 200th as a head coach on his 58th

birthday. "This was one of the most satisfying wins I've ever witnessed," he said. "I've been around better teams, but I've never been prouder of one than this one. The fact it meant so much to them to win you could sense on that bench."

Another important event took place in that 1971 game with USC at the Los Angeles Coliseum. At defensive end for Alabama was John Mitchell and at a flanker position was Wilbur Jackson. What made this noteworthy was that Jackson and Mitchell were black, integrating Alabama football once and for all. Mitchell had been recruited hard by USC after starring at Eastern Arizona Junior College.

After the win over USC, Bryant said, "We can't get fat-headed just because we beat USC. We're not going to be a good team if we do that."

Well, Alabama didn't get too fat-headed, I guess. It would finish the 1971 regular season undefeated at 11–0, which included its fifth Southeastern Conference championship under Bryant. Especially nice was a 31–7 win over Auburn. In that win, Johnny Musso ran for 167 yards in thirty-three carries, and quarterback Terry Davis passed for 105 yards, completing nine passes in eleven attempts. After the game, the team gave Coach Bryant a good shower, clothes and all. "You'll have to excuse me," Bryant told reporters. "I've got to get these wet shoes off or die of pneumonia. I know one thing. I'd rather die now than to have died this morning."

Alabama ended the 1971 season with a loss to Nebraska in the Orange Bowl. But it was plain to see for everyone: Alabama football was back. The Tide would be the dominant team of the 1970s, with the previously cited 97-11 record from 1971 to 1979 and national titles in 1973, 1978 and 1979. The Bear was shown to be right when he once muttered, "I ain't nothing but a winner."

ALABAMA AND DUKE THROUGH THE YEARS

I am lucky in that I write quite a bit about two of the best programs in the country: Alabama football and Duke basketball. Along with writing books on both of those sports, I have written articles on Duke basketball for *Go Duke The Magazine* and Alabama football for *Bama Magazine*, among others. I have found that not only am I connected to both programs, but also the two universities, Alabama and Duke, have quite a few interesting connections.

Of course, probably the most well-known connection is that Wallace Wade left Alabama to go to Duke in 1931. Coach Wade is generally given credit for putting Alabama football on the map, and for sure he is the man who put Duke football on the map. He won big at Alabama and won big at Duke. In fact, from 1932 to the 1942 Rose Bowl, Duke had the best winning percentage in the nation, going 80-16.

When speaking to Alabama fans, without a doubt the most frequent question I get is why did Coach Wade leave Alabama for Duke? One factor was that Coach Wade was ready for another challenge; he had established Alabama as a national power. He also wanted more autonomy to run his program as he wished. And, quite frankly, he was offered the then tremendous salary of $12,500 a year plus a percentage of gate receipts, so his total package was estimated at $20,000 per year.

Two of Wade's former players at Alabama went on to long coaching careers at Duke: Herschel Caldwell and Dumpy Hagler, who are both in the Duke Sports Hall of Fame. Coach Wade also brought his 1930 All-American tackle, Fred Sington, to Duke to be an assistant coach.

Bear Bryant grew up in Arkansas wanting to one day play for the great Wallace Wade at Alabama. The first game he ever listened to on the radio was Alabama's win over Washington in the 1926 Rose Bowl. Coach Wade and Coach Bryant remained friends for the rest of their lives, with Coach Bryant inviting Wade back to Tuscaloosa several times. Coach Bryant would often call Coach Wade in Durham, North Carolina, where Wade had retired on a cattle farm.

Wallace Wade chose Frank Thomas to succeed him at Alabama, and these two men were lifelong friends. In the late 1940s, Wade convinced Thomas to come to Duke University Hospital for treatment after Thomas got sick, suffering from high blood pressure. Wade was still coaching at Duke, and Thomas stayed a few nights in the Wade home and even attended some Duke practices when not in the hospital.

In 1945, Alabama lost to Duke in the Sugar Bowl in one of the most exciting bowl games ever.

Steve Sloan, quarterback for the Crimson Tide in the early to mid-1960s, became Duke's head football coach in 1973.

A connection today is that Alabama graduate David Cutcliffe is now the head coach at Duke. Coach Cutcliffe remains a staunch fan of Alabama, keeps a bust of Wallace Wade in his office and credits Bear Bryant for much of his football knowledge. In a 2010 interview with me for *Alabama Alumni Magazine*, Coach Cutcliffe talked about his Alabama days:

> *I was a student assistant to the football program. Quite frankly, I spent more time studying football than academics. The influence of Coach Bryant was enormous. I really studied how he did things, how he managed his staff and squad. What an opportunity I had, learning from the coaches at Alabama. I still have today a notebook full of things I wrote down while at Alabama, and I refer to those notes today.*

Alabama traveled to play Duke in 2010 in Duke's home stadium, Wallace Wade Stadium. Coach Cutcliffe said:

> *I have had a great rival relationship with Nick Saban, a great respect for what he's done. Boy we had tremendous games when I was at Ole Miss and he was at LSU. I appreciate Mal Moore (Alabama's athletic director) and Nick Saban bringing Alabama to Durham. There is the history between Alabama and Duke, the Wallace Wade connection, along with my ties to both universities. I have a bust of Wallace Wade in my office, which looks*

Nick Saban. *Photograph by Carol M. Highsmith from the Library of Congress George F. Landegger Alabama Collection. Courtesy of Carol M. Highsmith.*

down on the field at Wallace Wade Stadium. I know Coach Wade would enjoy this game, looking at the two football programs he built, so I think I'm going to position that bust of Coach Wade so that he can get a real good view of the game when we play Alabama.

29

A SOUTHERN BELLE

W ay back on April 24, 1908, a little girl was born in the small town of Letohatchee, Alabama. Anita was her name, and she grew up to be a beautiful young lady. She made many a young man's heart flutter during her days as a University of Alabama student from 1924 to 1928. Just recently, in 2009, at the age of 101, Anita Mitchell Caldwell sat with me in her home in Durham, North Carolina, and recalled her years at the Capstone.

Anita and her two sisters all graduated from the University of Alabama, and her father, J.B. Mitchell, was a college graduate from Auburn University, of all places. But after graduating from Prattville High School in Alabama in 1924, there was no question for Anita; she wanted to follow older sister Louise to Tuscaloosa. A few years later, younger sister Annie Laurie would follow Anita. Soon after arriving on campus, a Sigma Chi fraternity member, Bob Adams, asked Anita to accompany him to a dinner. While there, Anita caught the eye of one of Bob's friends, Herschel Caldwell. Herschel told a friend, "I sure would like to meet that girl with those pretty brown eyes." Well, after being told of Herschel's interest, Anita mentioned to a lady friend of hers that she wasn't sure, as she did not know a thing about Herschel. Her friend replied, "Anita! Look at him, he's cute, the vice-president of the student body and a star football player for the national champion Crimson Tide. What more do you need to know?" Herschel had gained some national acclaim after kicking the extra point that gave Alabama its second straight national championship in the 1927 Rose Bowl, playing for the legendary Wallace Wade. Anita agreed to talk to young Herschel, and they fell in love.

Anita and Herschel had to be careful because Coach Wade, a notoriously tough coach, frowned upon his players having girlfriends. Once, while walking and holding hands near the football office, Coach Wade stepped out, and according to Anita, "Herschel dropped my hand like a hotcake."

During the time of her student days, two or three female students were asked to be sponsors for each home football game, and Anita was chosen several times. The sponsor would sit on the Crimson Tide's bench during games and be introduced to the crowd during halftime. The ladies would be escorted on the field while holding huge bouquets of chrysanthemums.

Dr. George Denny was then the University of Alabama president, and Anita recalled him well. He always was seen around campus with a coat and tie, never casually dressed. "Dr. Denny was a very stern man, he really meant what he said," Anita recalled. "But he was also as friendly as could be and always put the students first. I remember back then, students' grades would be sent home to the parents. I still have one of mine that he signed, 'A fine young lady. George H. Denny.'"

When asked what female students did in Tuscaloosa after going to class and studying all day, Anita replied, "We dated!" There were a lot more men on campus than women at the time, so the ladies had many options. The "boys," as Anita calls them, mostly drove beat-up old Fords, what were known around campus as "tin lizzies." Girls were not allowed to ride in a car with a boy when going out of town. Also, a male could invite a female to dinner on campus only on Sundays.

In 1928, Anita graduated with double majors in home economics and English. By this time, Herschel was the head football coach at Sidney Lanier High School in Montgomery, where he won a state championship in 1928. Anita started teaching at Sidney Lanier after graduation and later taught at Montgomery Middle School. In 1930, Wallace Wade accepted the coaching position at Duke University and hired Herschel to be his assistant. Coach Wade had a year left on his contract so stayed through the 1930 season. But he sent Herschel to Durham to start laying the groundwork for when he arrived in 1931. While living in Durham in 1930, Herschel kept driving back to Alabama every chance he got to see Anita. Coach Wade got a little worried that Herschel wasn't staying in Durham enough and went to see Anita one day. She recalled, "One day Coach Wade showed up and said to me, 'Now you're not giving Herschel the run around, are you? I think you two should get married.' I thought that sure took some nerve for him to say that!"

Coach Wade went on to win Alabama's third national title in 1930. He went to Duke and established that team as a national power. Anita and

Anita Caldwell graduated from Alabama in 1928 and married Herschel Caldwell, an Alabama player. After Herschel accepted a job at Duke, Ms. Caldwell became a big Duke fan but always kept up with her "Alabama boys." Ms. Caldwell passed away in 2011 at the age of 103. *Courtesy of the Caldwell family.*

Herschel got married in 1933, and Herschel is now enshrined in the Duke Sports Hall of Fame after a forty-two-year coaching career.

Anita Caldwell had lived in Durham, North Carolina, since 1933 but still remembered fondly her first twenty-five years living in Alabama. To say she was an avid Duke football supporter would be an understatement. She had not missed a Duke home game since 1933, until health kept her away in 2010. Every Saturday for all those years, when Duke played a home game, this absolutely charming lady would be in her special press box seat cheering hard. "I always will be a fan of the Alabama and Duke boys," Anita said. "They have been a big part of my life all these years."

Mrs. Anita Caldwell passed away in 2011 at the age of 103, still in love with the two universities close to her heart, Alabama and Duke.

30

COACH GRYSKA

Clem Gryska is a man known by Alabama football fans all over the country. Coach Gryska, for many years, served as an assistant coach under Bear Bryant at Alabama and played at UA under Frank Thomas and Red Drew. Most fans of today know Coach Gryska from the Bear Bryant Museum in Tuscaloosa, where he worked and shared his knowledge of Alabama football. From 1960 to 1993, Coach Gryska was an assistant, so he was a big part of seven national championships, six under Bear Bryant and one under Gene Stallings.

Clem Gryska played high school football at Catholic Central in Steubenville, Ohio. He was the youngest of six boys. Toby Pierson, a Coca-Cola representative, recruited Gryska to the University of Alabama after seeing him play in an all-star game at Bethany College in West Virginia. Being an all-star high school football player and then playing at Alabama is quite an accomplishment for anyone, but Clem Gryska's feat is more amazing because he has only one hand. In Kirk McNair's excellent book, *What It Means to be Crimson Tide*, Gryska recalls the incident of losing his right hand: "I was working in a grocery store when I was 11 or 12 years old and lost my right hand in a meat grinder. The doctor did a great job to save the thumb, or I wouldn't have been able to do anything. I wrote and called him until he passed away. If he hadn't done that, I would have been helpless."

"In 1947," Gryska continued,